MURRAY FAVRO

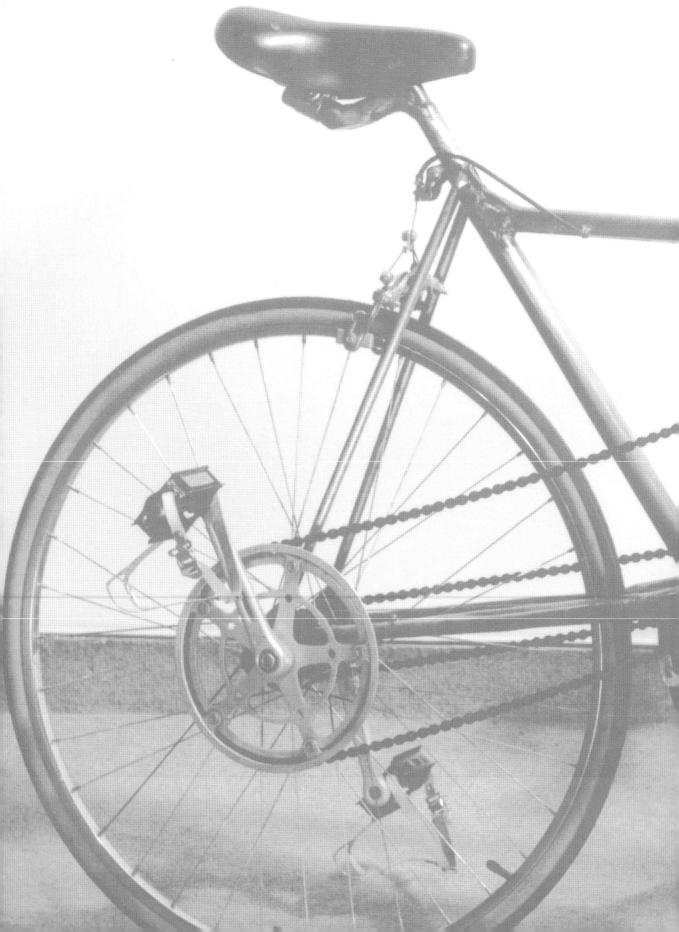

MURRAY FAVRO

Essays by Robert Fones, Helga Pakasaar,
Matthew Teitlebaum and Peter White

London Regional Art & Historical Museums

McIntosh Gallery, University of Western Ontario

MURRAY FAVRO

COVER
Bolex Camera (1998)

Published in conjunction with the exhibiton *Murray Favro*, held at London Regional Art & Historical Museums and McIntosh Gallery, University of Western Ontario, September 19 to November 8, 1998.

CURATOR OF THE EXHIBITION
Peter White

Canadian Cataloguing in Publication Data

Favro, Murray
Murray Favro

Includes bibliographical references.
Exhibition presented jointly Sept. 19–Nov. 8, 1998 by the London Regional Art and Historical Museums and the McIntosh Gallery.

ISBN 0-7714-2134-6

1. Favro, Murray–Exhibitions. I. White, Peter
II. London Regional Art and Historical Museums (Ont.)
III. McIntosh Gallery. IV. Title.

N6549.F38A4 1999 709'.2 C99-900073-X

EDITORS: Mary Anne Moser and Peter White

DESIGN AND PRODUCTION: Associés libres, Montréal

FILM: Grafix, Montréal

PRINTING: Imprimerie Renaissance, Québec

London Regional Art & Historical Museums
421 Ridout Street North
London, Ontario N6A 5H4

McIntosh Gallery, University of Western Ontario,
London, Ontario N6A 3K7

PHOTO CREDITS:
Chris Alred, London Regional Art & Historical Museums: 26/27; Art Gallery of Ontario: 12, 14, 15, 19, 37 (top), 86 (top), 89; Murray Favro (courtesy Montreal Museum of Fine Arts): 28; Ian MacEachern: 100 (top); Don Hall, Mackenzie Art Gallery: 43, 47 (top), 49, 50, 52 (left), 93; mach y derm: 9, 10, 11; National Gallery of Canada: 23, 48, 70, 86 (bottom), 88; Larry Ostrow, Art Gallery of Ontario: 34, 37 (bottom); Yaroslav Rodycz (courtesy Christopher Cutts Gallery): 54, 59, 60, 64, 68, 73, 77 (courtesy Oakville Galleries); John Tamblyn: front cover, 2/3, 8, 17, 24, 32, 35, 38, 39, 44, 45, 46, 51, 52 (right), 53, 63, 79, 83, 84, 91, 92, 93, 112, back cover; Don Vincent: 96, 99, 100 (bottom), 103.

In October 2014
CHARLIE HILL
gave this book to
ADAM WELCH

CONTENTS

PREFACE

IT IS INDEED a pleasure for the London and District Construction Association to assist in the sponsorship of the exhibiton and publication *Murray Favro*. This is a special donation in recognition of the Association's one hundred years of service to the construction industry and the City of London. By making this gesture we are restating our commitment to the London Regional Art and Historical Museums and to the arts community in our fair city.

Peter Beerda
President
London and District Construction Association

FOREWORD

AUDIENCES HAVE BEEN able to experience a significant body of work by London artist Murray Favro for the first time in fifteen years through an exhibition held jointly and simultaneously at London's two public art galleries, the London Regional Art and Historical Museums and the McIntosh Gallery. The exhibition together with this document testify to the ongoing creativity of one of Canada's most mature and productive artists whose career spans three and a half decades.

We are indebted to Murray Favro for his remarkable artwork, his cooperation and unfailing support throughout the project.

As the guest curator for the Murray Favro project, Peter White has been a driving force. His vision and commitment have resulted in a lasting legacy of an important Canadian artist and his times.

The project was conceived and the exhibition took place while former London Regional director Ted Fraser was at the gallery. His enthusiasm and support were instrumental to the project and are gratefully acknowledged.

The realization of this complex project is due in large part to the staff of our respective institutions who have worked collaboratively and efficiently, and we wish to recognize their special cooperative efforts and accomplishments.

A special thank you is extended to all the lenders for their generosity in sharing Murray Favro's work with a wider audience.

Finally, we wish to extend our gratitude to the funders who made the Murray Favro project possible: the Canada Council for the Arts, the Gershon Iskowitz Foundation, the London and District Construction Association and the Ontario Arts Council.

Brian Meehan
Executive Director
London Regional
Art & Historical Museums

Arlene Kennedy
Director
McIntosh Gallery

Rear Pedals Bicycle (detail) 1988

INTRODUCTION

Peter White

MURRAY FAVRO HAS BEEN recognized as one of the most significant, certainly one of the most inimitable visual artists working in Canada for the past thirty years. His explorations of perception, cognition, the relationship of science and art, his innovative use of materials and techniques – slide and film projection, computer and electronic technologies, lighting effects – and his active involvement in "noise" music and sound have been widely influential both in London and elsewhere for their insights about how the world is experienced, understood and constructed. In particular, Favro's "homemade" machines and mechanical devices that don't quite work and his elaborate perceptual schema not only expose orthodox attitudes about reality, but they also raise serious questions about art, technology, and the nature of representation.

From *Noisemaker*, 1998

Born in Huntsville, Ontario in 1940, Favro moved to London as a teenager where he studied at H. B. Beal Technical and Commercial High School, a virtually unprecedented local institution that offered serious training in the visual arts. With Jack Chambers, Greg Curnoe, Ron Martin, Royden and David Rabinowitch, John Boyle and others, Favro is one of a remarkable generation of artists who became active in London in the early 1960s. Widely collected and exhibited, Favro's work was the subject of a major retrospective organized in 1983 by the Art Gallery of Ontario.

Much as Favro benefitted from the expansion and increased opportunities of the Canadian artworld during this period, both that support for his art and the strongly modernist context in which it was formed and understood have tended to dominate the critical approach to his art. Notions of the avant-garde, anti-art and, especially, individual "creativity" (read: invention), while certainly essential critical ground, nonetheless are also restrictive categories that have limited assessment of Favro's art.

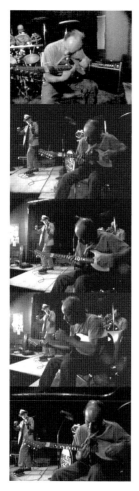

At the same time, having had a retrospective at a relatively early age, there has perhaps been less public attention paid to his work since that time.

In undertaking both a major exhibition and this publication, the intention of the London Regional Art and Historical Museums and the McIntosh Gallery has been to recognize and underline the accomplishments of one of London's senior and most important artists. Equally significant, however, is the opportunity this project has afforded for examining Favro's more recent work in relationship to his earlier production. Organized thematically rather than chronologically and presented at both galleries, the exhibition was conceived to contribute to an expansion of the critical framework for Favro's art. Notwithstanding their intellectual pedigree in modernist landmarks such as the work of Marcel Duchamp and the Constructivists, Favro's objects and activities are also the embodiment of a practice that raises issues of the local and community, of class and the everyday. While these have always been important aspects of his art, they have perhaps become more emphatic elements in recent years. As much as works such as *Studio Window* (1989) and *Hydro Pole* (1995-96), for example, are concerned with questions of perception and knowledge, they are also intimately connected to Favro's personal and social environment. The most recent work included in the exhibition, *SD40 Diesel Engine* (1998), is based on a model produced locally at the General Motors plant in London.

Similarly, while there has always been understood to be a relationship between Favro's art objects and his involvement in noise bands (both the Nihilist Spasm Band and The Luddites), the emphasis here has tended to be focused on questions of spontaneity and creativity. Yet in the case of the Nihilist Spasm Band, which has been playing on a weekly basis for the past twenty-five years, Favro's approach to sound has been as a participant in a group activity dependent on accrued collective, as well as self, knowledge. One of the objectives of the exhibition was to consider Favro's involvement in sound from a perspective that encompasses his music within an overall art practice that is strongly interdisciplinary and, indeed, has strong communal and performative aspects. Towards this end, one gallery of the exhibition was dedicated to Favro's guitars, meta-sculptures made to discover what sounds they produce yet which also function within an art economy. Likewise, the guitars are the subject of a section located near the centre of this publication (although, it must be noted, it has only been possible here to allude to the driven sound that was introduced into the exhibition through excerpts of Nihilist Spasm

Band recordings, a Favro-Greg Curnoe duet, and *Noisemaker*, a seventeen-minute documentary produced for the show).

Since 1983, Favro has been extremely well served by the remarkably comprehensive catalogue produced by the late Marie L. Fleming, curator of his Art Gallery of Ontario exhibition. With this publication, the intention has been to both develop an expanded theoretical framework and bring new voices to the discussion of Favro's art. In examining his early career, Matthew Teitelbaum, Director of the Art Gallery of Ontario, relates Favro's art to a world of everyday mechanical objects and community interaction. Favro's projections are linked to a history of the "industrialization" of vision by Helga Pakasaar, Curator of Contemporary Art at the Art Gallery of Windsor, who also addresses their insistent relationship to the body. Through his detailed studies of a series of recent works in which Favro has investigated handmade objects, Robert Fones, himself a highly regarded artist who at one time worked with Favro in London, pushes to a provocative edge of metaphor the remarkable complexity and materiality of even the most seemingly simple of Favro's devices. My own text considers questions of context, locating Favro's work in relationship to technology, perspective and the everyday.

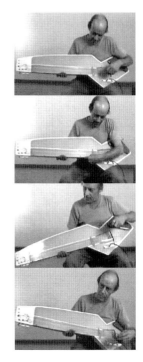

It might finally be added that if this project has provided an opportunity to examine the achievements and critical context of a durable career, it also has a significant timeliness, one that places Favro's work squarely in debates and concerns of the present moment. As one writer has noted, Favro "transposes scientific principles largely established in the nineteenth century into late twentieth-century objects....That he does so at a charged and focused moment in the revolution in internet-driven communications systems, suggests his work is not so much a cautionary tale as a challenge to utilize technology to achieve a purposeful sense of community."

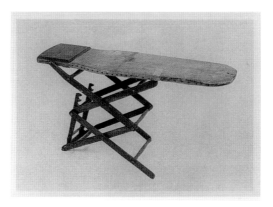

C. B. Francis
**Improved Window-Blind
Fastener 1867**

O. A. White
**Improvement in Ironing-
Tables 1877**

M. R. Bissell
**Improved Carpet Sweeper
1879**

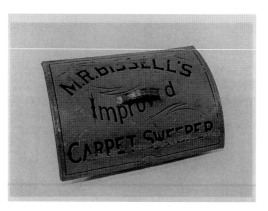

MURRAY FAVRO

FOUR PROPOSITIONS FOR FINDING THE ART WORLD BY LOOKING THE OTHER WAY

Matthew Teitelbaum

December 12, 1996: The catalogue comes in the mail, and it is unexpected – a collection of 200 objects, all models for inventions submitted to the U.S. Patent Office. They are ideas in miniature, rendered both to work and to manifest an idea. Some are familiar – the M. R. Bissell Improved Carpet Sweeper, the [Edison] Automatic Telegraph, O. A. White's Improvements in Ironing-Tables – and some absolutely new – the Improved Window Blind Fastener, the Improvement in Railroad-Station Indicators, and the Improvement in Side Saddles. Those familiar were, by commercial standards a success, those unfamiliar likely never produced. All are equally fascinating, rendered from finely crafted materials to look like something real in our world, however other-worldly they seem. I found myself associating these objects of invention with the work of artists I had long admired. I thought of Murray Favro. These objects linked the function and display of objects and I could not get them out of my mind for a long time.

THE DOMINANT HISTORY of twentieth-century sculpture seems a world apart from the achievement of Murray Favro. The high modernist tradition of rendering roughly recognizable forms in carved stone or poured bronze, or constructing assemblages of discarded industrial refuse, stand a generation away (at least) from Favro's own work. Herbert Read, the great British critic, heralded the virtue that lay at the centre of this tradition when he wrote in 1964 of sculpture "conceived as an art of solid form, of mass, [with] virtues related to spatial occupancy." Favro's idiosyncratic objects are much more than that.

Not surprisingly, Favro's achievement is tied precisely to that moment when high modernism gave way to its virtual opposite – an art filled with conjecture, humour and the materials of the natural world. The art-making movements of the late 1950s and 1960s – Pop sculpture,

Most people I knew [as a kid] just went to work and came home. But this [inventor] was working on his own, on these really interesting things.

[Murray Favro in conversation with Marie Fleming, London, Ontario, May 26, 27, August 24 and September 13, 1982]

I try to obtain a functioning object – only in this way can I avoid phony, surface objects.

[Murray Favro in conversation with Marie Fleming, London, Ontario, May 26, 27, August 24 and September 13, 1982]

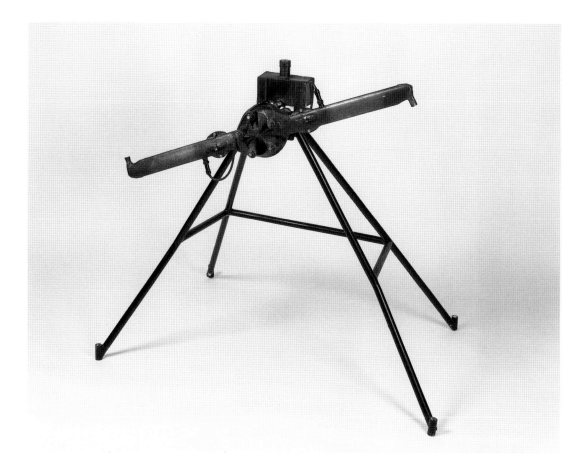

Would like to have a stereo sound in a frequency you couldn't hear but could be aware of. The stereo would be varied and would cause an awareness that would be like a trip through your mind frequency changes etc and see what it does.

["Murray Favro's Journal," *20 Cents Magazine*, vol. III, no. 3/4 (May 1969)]

three-dimensional Op objects, kinetic sculpture, *Arte Povera* and even Earthworks – were signposts for Favro, nothing less than an invitation to a new world. It is not that his work came to look like three-dimensional objects by contemporary artists such as Claes Oldenburg, Robert Smithson or Luciano Fabro, or even that they began with such similarity when Favro first began to make art in 1965. Rather, it was the spirit of breaking consciously with the past of conventional material and form-based subject matter that united them.

Favro was urged towards his practice not by a stylistic declaration he shared with other artists of his time, but by the spirit of experimentation that he and other artists of the sixties willed for themselves. Like his peers laboring in the shadow of Duchamp, the moorings for sculpture's traditional purpose held little sway. The nineteenth-century idea of memorial, for example, or the commitment to ornament that marked sculpture at

the turn of the century, were of scant interest to him. Nor did the late modernist dialogue with the built environment have much of a hold, privileged as it was by site-specific public commissions in the 1960s and 1970s. These purposes seemed alien to a process of making art, and were simply not a part of Favro's experience. Favro's world was one of invention and experiment, of creating out of the principles of homegrown science. Since the mid-1960s, Favro has made model airplanes, propeller engines, wind tunnels, playable guitars and telephones. These objects, layered in meaning, are declarative and enigmatic at the same time, and his work simply looks different then, as now, than most objects we think of as art-world sculpture.

The inventor/experimenter becomes an artist by virtue of the objects he makes and the purposes they serve. Favro has never been satisfied by purely aesthetic responses to objects, nor interested in traditional narrative, the storytelling qualities of sculpture. In all that he does, Favro is engaged

Art is not conceptual first...Not an answer to a question (first)...It is experience first.

["Murray Favro's Journal," *20 Cents Magazine*, vol. III, no. 3/4 (May 1969)]

in describing a process of mechanical operation, and communicating the principles of such operation in visual form. Simply put, he links the process of looking to a process of figuring out how things work.

It is, curiously, one of the enduring qualities of Favro's work that, while seemingly at such a remove from the grand orthodoxies of the art world, his objects seem to embody a central quality of art itself – directed imaginative play. His engagement with objects is determined through the lens of essential art-making processes: he makes objects that stand as evidence of individual responses to ideas; he works not through a process of transcendant inspiration but through careful observation. His objects engage the viewer in a process of unravelling those very principles of operation and sight. These three fundamental qualities of Favro's art – individuality, observation, engagement – are the constants of his achievement, and link all the disparate objects he has made since his first exhibition as an artist some thirty years ago in his adopted hometown of London, Ontario.

Proposition One: The Territories of Art are Tied to Place

Favro became an artist in London, and London became a city of art in no small measure because of Favro's ambition and achievement. In 1965, London was a city with a population of 160,000. It enjoyed a sustained reputation as a city of solid civic virtue with a conservative though unbendable tradition of art making and art teaching. The curator of the local gallery, Clare Bice, was a professional artist (as were the directors of nearby sister institutions in Windsor, St. Catherines and Hamilton) and, for many in London, Bice was the figure of the responsible artist. As a painter whose formal simplifications, and sometimes bold colour, served to animate conventional subject matter, he epitomized the safe edge of the modern movement.

If there was a balance in the London art world, it was provided not through the examples of other senior artists of achievement, but through teaching practices that opened up possibilities of thinking about art in new ways. Favro studied at H. B. Beal Technical and Commercial School, where the art program had distinguished itself, first as an academic training ground and, in later years, as an environment that provoked a younger

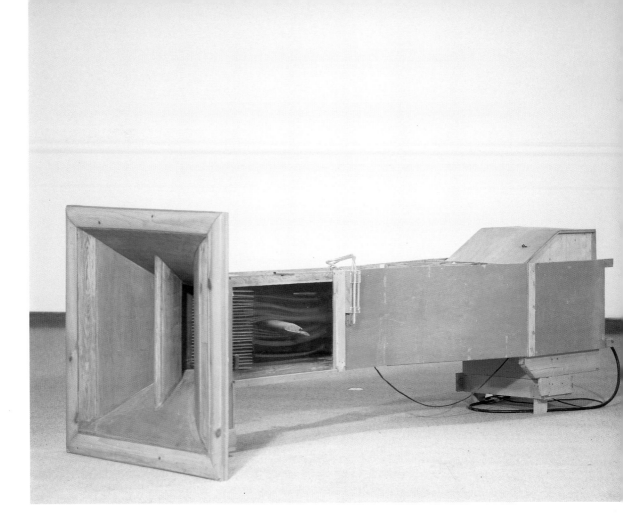

Wind Tunnel 1990

generation to approach subject matter in truly personal ways. Favro's teachers (principally Herb Ariss and John O'Henly) believed that art was a process of fixing a place in the world, thereby defining those values that rooted you there. Students were encouraged to look at works of art from key international centres, and to link visual arts to writing, music and cinema. Favro (who had yet to exhibit his work) was encouraged to look at artists from diverse fields of activity, challenged to question a great deal of accepted tradition, and expected to question those orthodoxies that made the London art world seem unshakably solid.

This process of self-actualization, a provocative teaching method tied to a grounding in the foundations of traditional art-making techniques, was reinforced for artists of Favro's generation by the example of Greg Curnoe. Slightly older than Favro and his fellow students, Curnoe had returned to London in the summer of 1960 from unsatisfying study in

The contemporaries I met shortly after getting my first studio on Dundas Street were John Boyle (self taught as we all really are anyway), Bernice and Don Vincent and Jack Chambers. The Rabinowitch brothers soon after this come to London for other reasons than art (Royden for music, and David came to go to UWO). The Rabinowitches met us through a mutual friend, John Clement. It is of importance to realize that what was going on around us was not just an exclusive "artist talking only to artist thing." John Clement is a member of the Nihilist Spasm Band that is still active today; also John and I raced motorcycles in such places as Mosport, and Hairwood. Other people around at the time were Hugh McIntyre, Art Pratten, Bill Exley, and other poets and writers. The common thing we all had was that each person was an individual and would pursue a personal way of seeing and making art.

[Murray Favro, e-mail to Matthew Teitelbaum, December 21, 1998]

Toronto with a stubborn (and lifelong) conviction that the stuff of art was irrefutably tied to local conditions and everyday subject matter. More so than any other artist from 1960s London, Curnoe argued for the ideal of a self-realized city that rejected models of achievement set by larger centres. In various writings, lectures and workshop discussions, Curnoe celebrated local experience as true content for art. This acknowledgment, Curnoe argued, would affirm and create a sense of ambition for artists rooted in the realities of life in London.

Affirmation of place was a staple of art conversation in the London community. Conceiving of London as an active environment linked artists of diverse temperaments and influences. Curnoe and the representational painter Jack Chambers, who by the mid-sixties were the most acknowledged of the younger generation of artists, shared an interest in the history of London, and a conviction that it formed the foundation for their art. Though in style and manner their paintings looked very different, Curnoe and Chambers shared a worthwhile skepticism about the history and traditions of painting practices as they had been received in London. Working within the languages of a painting practice, each challenged its processes. Curnoe layered the conventional pictorial narratives of painting by adding assemblage elements and written texts to the surface; Chambers developed a carefully worded manifesto that positioned painting not as a process of traditional representation but as a ground for articulating the consciousness of sight.

Favro shared with both Curnoe and Chambers a skepticism about received ideas, and a belief in the value of local culture. Unlike them however, he did not use his related connection to London and its environs as a stage for content, in the literal or associative sense. His connection came from a simple belief that the act of invention and its corollary, creation, could happen anywhere. In his belief that connecting to 'place' provided an important sense of community and support for such invention, Favro related the idea of place to those artists who shared his feeling that dominant centres were created by market forces and not the inherent importance of the projects they nurtured. *Propeller Engine* (1978) is a work about place simply because it came into being in an environment in which artists were palpably connected to Favro's project, an enquiry into space, exploration and the laws of physics.

Proposition Two: The First Principle of Art is Observation

At a time when critics were comfortably declaring the "death of painting," skepticism about the painter's practice in the age of super-8 film and the omnipresent photograph was widespread in London. Favro approached the question as an object maker. Aware of the histories of painting, Favro, his contemporary Ron Martin and others, moved to create objects that had the processes of painting as content. Favro created wall objects that materialized the movement of paint and the principles of gravity. Paintings such as *Sproing* (1965) and *Clunk* (1966) captured the changing state of a painting or object over time. Ron Martin created works that made visible a related transformation in the apprehension of an object, albeit from a different point of view. Martin paired identically imaged "conclusions" and "transfers" in a manner that underlined painting as a process of moving towards the realization of an image through various stages of consciousness.

Favro wrote of just such an experience — seeing paintings as objects that were neither narrative in content nor minimal in form, noting somewhat incredulously that "lately some artists have become aware that traditional painting has almost always been concerned with images of objects. Instead of objects," Favro applauded Martin's *Conclusion* and *Transfer* paintings as "paintings that looked at themselves as objects yet [were] not... sculpture." Favro noted his own admiration for the shaped canvases of the American painter Frank Stella. Later, writing of the manner in which one is made conscious of the principles of sight by apprehending an object, Favro said Op art taught him that "besides looking and interpreting, the sensation of the painting is the experience."

By concentrating on the observable physical properties of painting itself, Favro began to address the principles by which an object is materialized. It was, in short, a way of describing the qualities of an object by the conditions that allowed it to exist. Much like other artists of his community — David Rabinowitch and his brother, Royden, Dave Gordon, Steve Parzybok and later, Paterson Ewen — Favro was interested in the idea of phenomenon. Favro contributed regularly to the London artists' paper, *20 Cents Magazine*, and wrote of the role of phenomenon in his work and

Sproing 1965

Oil and automotive paint on hardboard,
three steel springs
200.0 × 300.0 cm
Art Gallery of Ontario
[not included in the exhibition]

"[David Rabinowitch] wanted to make an object that you couldn't memorize...You had to be there and look at it. It had to be an event, not an object, even though you see it as an object...I think there's a bit of that in my stuff too, but I don't state it like he does."

[Murray Favro in conversation with Matthew Teitelbaum, London, Ontario, June 11, 1998]

that of his peers. For him, phenomenon was rooted to the act of observation, and was tied to a description of how something worked. When Favro wrote of phenomenon as an attribute of art, he did so with the sense that in both its look and operation, a work revealed the conditions by which the viewer could understand what was being looked at. In doing so, he made clear the essential distinction between how something works and its usefulness. Favro was not interested in usefulness as a conventional definition of practicality. As David Rabinowitch said often to Favro, "Phenomenon is what you look at and can't memorize."[1] Looking, and the experience of looking at reality through illusion, is at the heart of Favro's first two projections, *Washing Machine* (1970) and *Light Bulbs* (1970). In each case Favro presents us with objects animated not by a material property, but by non-material light itself. It is as if Favro wants to emphasize that the act of seeing is tied to the very properties of light that brings objects to life and gives them the fullest sense of form.

Proposition Three: Art Expresses Individuality

Art for me could be a function itself; but more than that, it is about functions and relations of functions.

[Unpublished and undated notes by Murray Favro]

A factory is made up of various linked units: the workshop, the manufacturing area, an assembly line. Each is a unit with distinct sociological characteristics. The factory reflects the formal organization of industry, which is tied to three blueprint characteristics: it is deliberately impersonal; it is based on ideal relationships; it is rooted in the assumption that competition leads to maximum productivity. An industry is a community in microcosm, a controlled community, that is, with fixed roles for all of its protagonists. Within the factory, things must be done as directly as possible, and the recipe for true efficiency lies in the elemental value of rote work. The development of product, the games of trial and error, of supposition and field test, of experiments around cause and effect, of the spirit of invention, all happen outside the walls of the factory, for the factory, put clearly, is the commercial materialization of a creative idea developed elsewhere.

Murray Favro's art comes from elsewhere. His art of invention is the direct counter to the factory ideal of production and all it implies. Invention, which is an individual and solitary pursuit, is in contrast with production, which is typically communal, and often corporate. As Favro

explains, as with an artistic process, the inventor begins on a hunch. Invention starts with instinct, tied to the articulation of a problem to be solved. The inventor goes about proving a hypothesis, and one thing becomes clear: as the process is developed, the problem, or at least the definition of success in relation to the problem may change. "That's the whole joy of making the thing," Favro notes, "to discover as you go along."[2] He sees that his art mirrors his belief in the individual, and the power of solitary creativity. Remarking on the time when, in 1965 he began his first scale model airplane, Favro says simply, "At that time I was thinking about how much an individual could do as opposed to a large group of people."[3]

Favro had long been skeptical of planned obsolescence, that quality of the capitalist economy that makes perfectly serviceable tools and products redundant or unserviceable. It seemed to him that such arbitrary or commercial decisions to "invent" something new when there was no particular need for improvement was anti-art, anti-creativity. He saw it as a false inventiveness that tied the inventor to the efficiencies of factory production rather than the urge to create an object that created a new space for itself in the world. To make an object out of the spirit of inventiveness was to create an object that had a self-proclaimed and evident autonomy. In the great traditions of twentieth-century art (rather than the mechanics of interdependent economies), Favro believed in the object that functioned exclusively for itself.

July 21, 1998: Favro's studio has about it the sense that things are being made from materials at hand. Machine parts, uncut plywood, fastening devices that lie about, suggest no grand plan. They seem to be objects that will be used to suit a purpose other than the purpose for which they might have been intended. It seems like the studio of a bricoleur, a gatherer, a wanderer who, on his travels, picks up things that are later found to have use. And the bricoleur puts these things to use.

There is one project on the go here, the recreation of a locomotive on a train track, but there is evidence that other projects have been started and abandoned. There is order in a certain sense, as if Favro could reach for something to become a part of something else. But there is no factory-neat order, no evident and describable sense of one step leading to the next. The working operation here is not transparent to the visitor. Where I stand with the artist there is truly only room for one.

It takes...hundreds of people to build one of those jets. Can a person do it, just do the work yourself?

[Murray Favro in conversation with Matthew Teitelbaum, London, Ontario, July 5, 1998]

I cannot describe what it was like to know it was 'something' that I had never seen before...My mind raced ahead to other possibilities; some I ruled out as I tried them and saw they didn't suit the new medium or the way I work.

[Unpublished and undated notes by Murray Favro]

Proposition Four: Art Demands Engagement

One thing that hung in my mind while reading your piece is this: At the end of all these things that I do to make my artwork, I finally stand back and look at what I've done as a piece of art. On my own terms I may reject the piece, and it would soon find its way to the dump. The judgment is a visual one with no references to art history or logic of any kind.

[Murray Favro, e-mail to Matthew Teitelbaum, December 23, 1998]

Favro believes in the idea that objects function within themselves, but believes that objects become art when they are of interest to those who look at them. All objects are, in a sense, nothing more than a series of interdependent parts that play off one another and create a coherent whole; it is (in the spirit of Duchamp) the viewer's active engagement that completes the work of art and makes of it more than mere invention. Favro takes an idea, and through a process of experimentation, makes it an object to be experienced.

To look at *Van Gogh's Room* (1973-74) is to feel one's body within a painting. It is a construction that begins with empathy, through the question: "what would it feel like to feel the off kilter perspective of the painting as an experience that is fully three dimensional?" At its core is the riddle of whether an object or image can be both illusion and reality simultaneously. The question of whether something can look like one thing but in a material sense be something else is a constant in Favro's work, and continually linked to the experience of the viewer. If the recognition of seeing or experiencing something from two points of view is the challenge, the impossibility of reconciling the two is ultimately and resolutely the conclusion. *Synthetic Lake* (1972-73) at first, and then *Wharf on Skeleton Lake* (1994), are about an optical play on the surface of an object, and the structure or object which hosts the image is everywhere present. The power of each work prevents us from being seduced into seeing them as object and image at the same time. Rather, the experience is an oscillating one, where identity as object or image is unstable between two possibilities. Phenomenon is the act of seeing, and we see both surface and object, that is light and mass, one at a time.

August 3, 1998: In preparation for writing, I begin to leaf through Greg Curnoe's papers, finding myself happily engaged in an evocation of London from times past. Here are the artists talking to one another, writing, trading ideas, witticisms and sheer banalities. All of this is before me as I search for evidence of Curnoe's time with Murray Favro, two artists bound by an enduring friendship. I come across only a few letters, two somewhat flavourful (if not content rich) tape recordings, drafts of public texts by Curnoe about Favro, and some exhibition invitations. A letter catches my eye. This slightly creased page is filled with the run of a ball point pen, reflecting Favro's interest in the literal and the illusory. "Perhaps you have returned from your

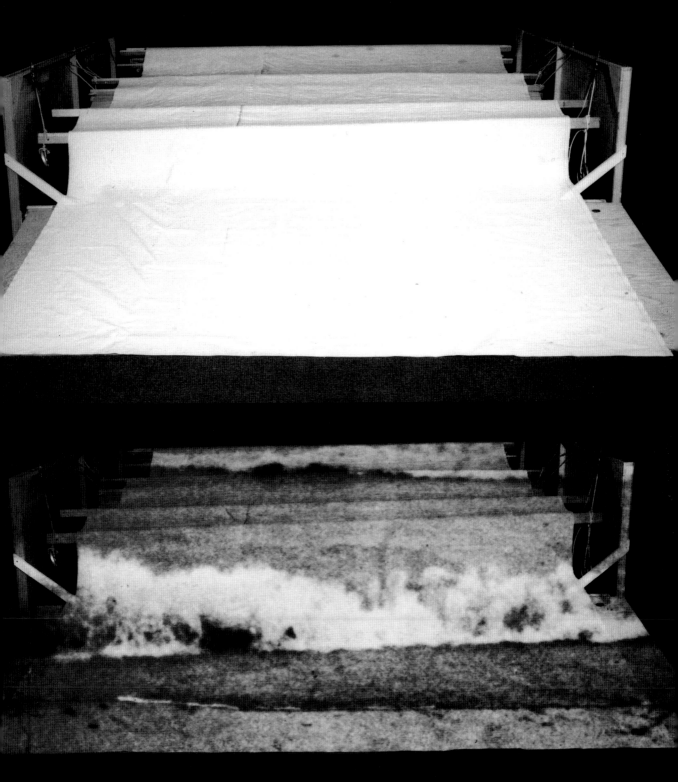

Synthetic Lake **1972-73**
16 mm colour film loop, projector, wood, canvas, rope, electric motor, metal fittings
2.9 × 6.1 × 12.2 m
National Gallery of Canada
[not included in the exhibition]

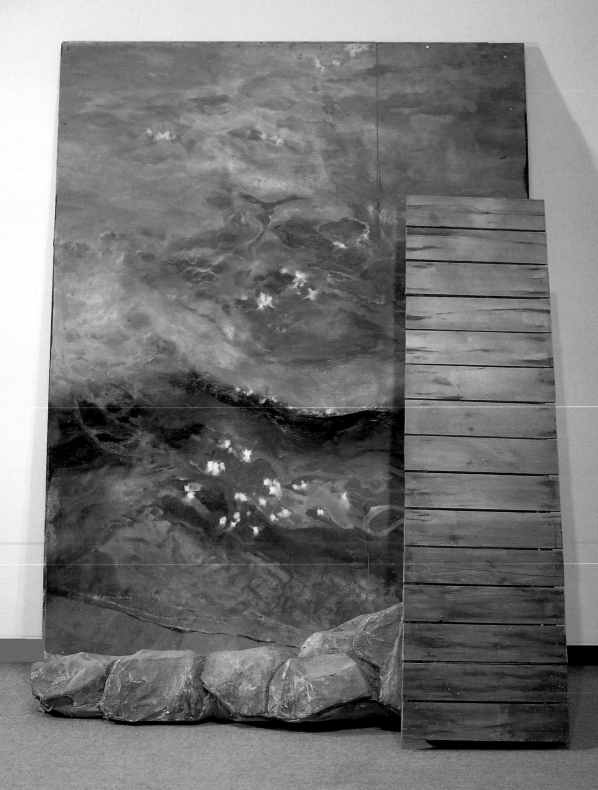

Wharf on Skeleton Lake 1994

trip by now," Favro writes from Huntsville on July 15, 1971. "Perhaps you are still away and cannot read this." It is, like Favro's art, both descriptive and elusive, a description of fact and a purposeful confusion of the site and time of experience. I am reminded of Favro's fancifulness tethered to a belief in severe functionality. I am reminded of Murray's mischievousness and seriousness. I return to his fancifulness: the equivalent of an exotic feather stuck in the chinstrap of a newly designed, and smartly efficient, motorcycle helmet.

Notes

1. Murray Favro in conversation with the author, London, Ontario, July 5, 1998.

2. Ibid.

3. Ibid.

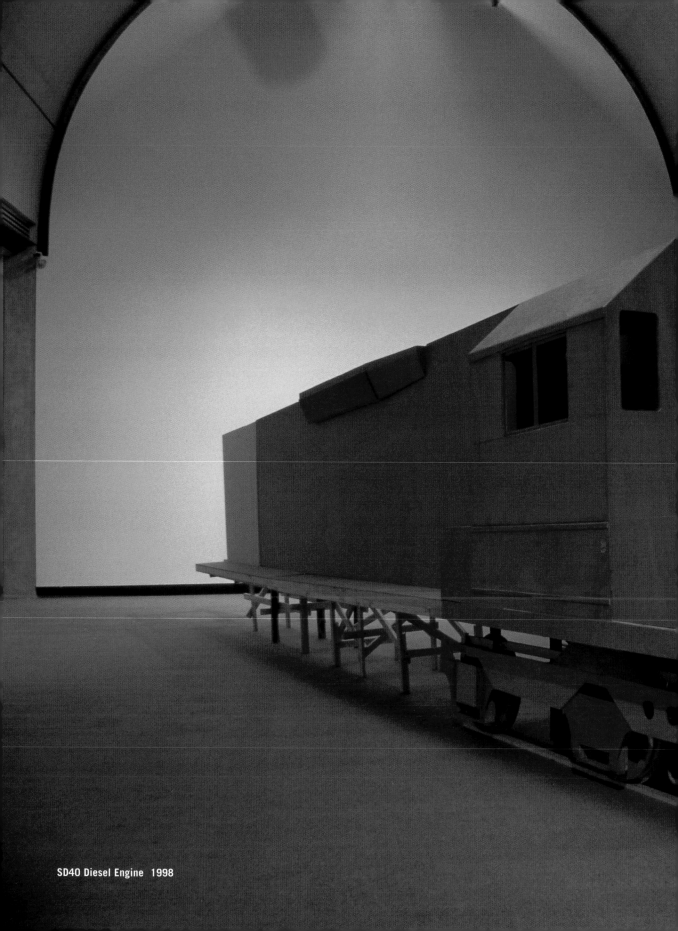

SD40 Diesel Engine 1998

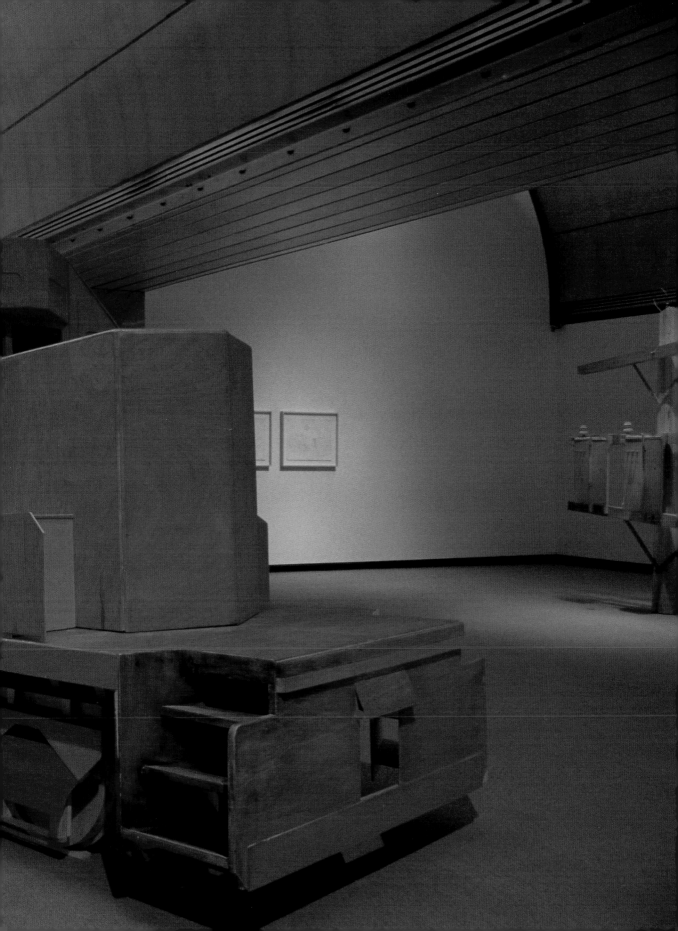

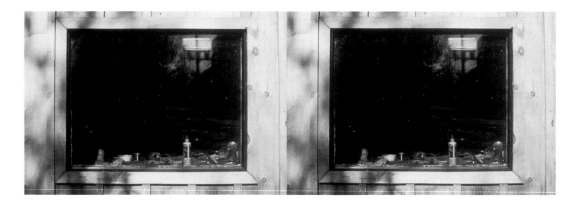

Studio Window (detail – left and right images) 1989

Left and right images are simultaneously projected onto a wall but are seen alternately
because of a mechanism that cuts off one image at a time by rocking back and forth
between left and right slide projectors.

MURRAY FAVRO'S SENSE EXTENSIONS

Helga Pakasaar

SOME THIRTY YEARS prior to this exhibition, Murray Favro claimed that "my body is an extension of me and a machine is a further extension."[1] He continues to explore the intersections between humans and machines through artworks that are indeed extensions of nature, the senses and the social. Since the 1960s Favro has carried out a sustained inquiry into the impact of technology on daily life. Machines determine how things are done and, as tools for negotiating everyday tasks and social communication, prescribe human experience. They are the 'nature' of modern culture. Favro responds to this social condition by making objects that reveal the language of machines. His approach to artmaking belies easy distinctions between art and applied science and is aligned with pataphysics – the science of imaginary solutions and the particular. This exhibition, then, can be seen as an assemblage of technical experiments and proposals, imaginary solutions posing as art.

As producers of visual experience, artists are especially influenced by technologies of perception and the progressive industrialization of vision. Murray Favro began producing art in what Marshall McLuhan called the "electric age of information technologies" and continues in today's post-mechanical world of digital culture. Thus a wealth of new perceptual tools and "advanced" technologies have been available to him. Ever skeptical of technological determinism, though, Favro has focused his attention on the more anachronistic technologies of common mechanics that tap into popular imagination and cultural memory. His devices reveal the underlying principles of technological innovation in a celebration of inventiveness itself. These low-tech objects make evident the simplicity of certain mechanical ideas that are normally hidden in more complex automated systems. By revealing the human consciousness mirrored in automated things, the artist in effect humanizes technology. Unlike the supposed body/machine synthesis of cyberspace, Favro's sculptures – whether replicas of simple tools or complex machines – are experienced as prosthetic extensions of the body. Even though they are dysfunctional as machines, they provoke a sense of potential motion and sound that is experiential.

The essence of a machine, according to the artist, is its alignment of functions. Often based on engineering prototypes from pre-industrial history, Favro's sculptures underline the relevance of certain historic inventions whose forms constantly reappear. The anvil or light bulb, for instance, is a simple yet refined concept that needs no improvement and is far from obsolete. Similarly, his fascination with the water-wheel and its various manifestations – propellers, locomotives, turbines and steam power – attests to the ingenuity of one of the oldest sources of mechanical power. The artist's McLuhanesque perspective posits that the significance of these cultural objects is ultimately how they affect social relations.

The artist is preoccupied with motion-activated and time-based devices that give concrete visual form to interactions between natural phenomenon, human labour and technology. Natural forces – air, water, light – are harnessed as energy to activate the works. Favro's various contraptions also invite human intervention, as they wait to fulfill a function, or simply to work. Similar to the artist's open-ended music that lets sounds be themselves, these sculptures involve a sense of play. There is pleasure in simply watching them work. In a society that has long been considered an efficient unstoppable machine, Favro's micro-view underlines our interactions with technology. The same principle that at a small scale (a bicycle) makes perfect sense, at a monumental scale (a hydroelectric power plant) seems remotely omniscient. All the more reason to understand the impact of basic tools of mass culture integral to daily life. Thus the artist's fascination with modest technologies that express the ongoing interaction and exchange with their surroundings.

Mechanical analogies developed for modern life early in the century, such as Constructivist utopias and the Futurist claim that the only valid subject for art was "our whirling life of steel, of pride, of fever and of speed," have proven to be nostalgic for the future as well as the past. While Favro's sensibility is couched in the visionary technological imagination of the nineteenth century, it is decidedly grounded in the vernacular and unheroic. With the do-it-yourself certainty of an amateur, his approach acknowledges the power of the particular and of inductive reasoning. Avoiding any utopian or dystopian polemic on technology, Favro's deep respect for mechanical things draws out a poetic, and at times melancholic, reading of the ambitions of industrial culture. Several of his painstakingly labourious re-creations of engineering feats are icons of failed technology such as the ill-fated Flying Flea, Avro Arrow airplane and Corvair.[2] Favro's models of power machines associated with mass production and specialized knowledge are stripped of their authority as techno-wizardry. They become demystified through the material rendering of what is often basically a simple idea – wings on air, light on object.

Favro's sculptures are obviously handmade and home-crafted. Whether made of industrial or natural materials, rough finishes and irregularities are maintained. This off-hand approach is that of the bricoleur who, recycling what is immediately at hand, favours an

aesthetic of contingency. At times quite tenuous and crude, Favro's sculptures suggest uncertainty rather than the more positivist implications usually associated with technological objects. Through an economy of means evident in ad-hoc construction methods and a preference for generic industrial materials like plywood – itself an example of technologized nature – the principles of adaptation and improvisation are given visual value. Skill resides in expressing the conceptual finesse of a good idea, rather than in decorative flourishes of craft. He is drawn to things that are both clever and clumsy. Favro's apparent disregard for the ultra-modern and high-tech validates the ingenuity behind commonplace things, as do his sources for easily accessible knowledge – popular science, technical manuals and home computers. This gesture of disaffiliation from power structures, elite systems of knowledge and art-world conventions acknowledges the importance of making the processes of art compatible with its content.[3]

Quite the opposite of the proclivity amongst contemporary artists to emulate the processes and look of mass production, Favro turns products of industry into a decidedly human activity. Most of his work results from an engaged interaction with various machines and involves a protracted processs of tinkering, experimenting and jerry-rigging. The thought processes that go into making things work is also evident in his preliminary sketches that resemble technical drawings. Since Leonardo, but especially in the twentieth century, the figure of the engineer has served as an exemplary model for visual artists. The Constructivist ideal of the artist-engineer, for example, proposed that artistic freedom and the functionalism of applied science could be compatible. This ideal continues to be embraced by the many contemporary artists who use industrial and electronic technologies. Murray Favro, on the other hand, assumes the role of artist-engineer with more than a hint of irony. While fascinated by and taking unabashed delight in the elegance at the root of technological innovation, he strips it of any prowess. His mechanisms – most of which are associated with male activities – are like demasculated toys whose pathos is accentuated in light of contemporary industrial culture.

Since the early 1970s, Favro has produced a number of pieces incorporating film or slide projection. In these "projected reconstructions" (as the artist calls them), a preoccupation with technologies of perception is directed to an investigation of seeing machines, namely the camera. An enduring concern with the impact of motion on perspective, already evident in his early paintings, here becomes more experiential. Perceptual phenomena produced by the mechanics of a camera are reconstructed in actual space. An integral part of each piece is the projector, as if a stand-in for the artist as conjuror. With the presence of a viewing apparatus, optical illusions are literally made visible. A transparent overlay of surface detail on corresponding three-dimensional shapes confounds delineations between substance and appearance. Concepts of light, image, illumination and picture become confused. Typical of the medium, the projections create a dazzling image, yet one

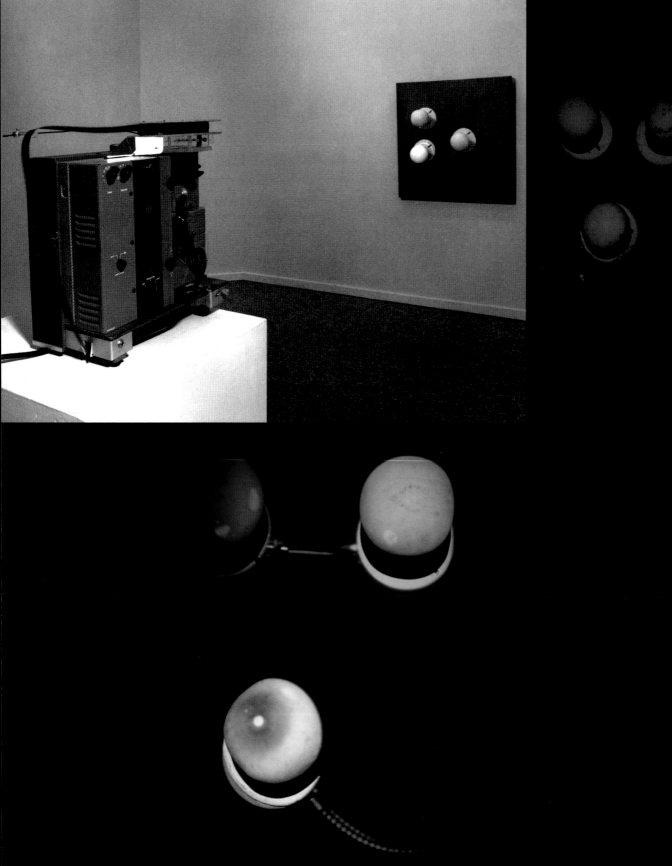

Light Bulbs 1970

that is usurped by an overpowering visuality effect, giving the impression of having the experience and watching oneself have it at the same time. Through a series of tautological loops, then, the works continually refer back to their production and to the viewer as producer.

An important part of this loop is the embodied observer. Unlike the invisible mechanics and bodily displacement of electronic media, this technology exists in real time and space. What initially appears as an illusory spectacle dissolves as the spectator is compelled to move through its luminous space to connect interrelated views. Perception thus is a sensory experience grounded in spatial relations. In keeping with the artist's concern with communal experience, the observer shares the space of the object. Reaching beyond issues of art and perception, the projected reconstructions trigger an acute awareness of perspective as a matter of where you stand, both literally and metaphorically. These works are an extension of the artist's fascination with motion machines (bicycles, skis, trains, cars, airplanes) that have profoundly altered our sense of time and space (perspective) and bodily sensation through speed. Several of Favro's recent sculptures are constructed as if already in perspective. This foreshortening – similar to the distortions of anamorphosis – creates an inclusive effect. Unlike the distanced, fixed viewpoint of Cartesian perspective, here object and subject collapse into an intimate space of anecdote and personal narrative. For Favro, perception is invariably embedded in the material history of social relations.

Born of the coincidences of science and art, cameras represent the machinations between industrialized vision and human perception. The camera as an apparatus inherently tied to the body, the eye, denies the autonomy of vision. Like the bicycle, the camera remains an essentially simple machine that relies on the transfer of natural energy, despite the increasingly sophisticated systems of its production and operation. The development of camera technology is inextricably tied to the history of science and industry. We might still ask whether it was the ability of photographic technology to isolate images of bird flight that led to the development of the airplane. Early optical devices such as the Claude glass and camera obscura produced images that, it was said, mirrored the outside world. A picture seen through a lens gave proof of the existence and order of things. As a paradigm of knowledge and truth, however, by the early 1800s the camera's authority was in dispute for, as a mode of representation it was linked to the corporeal subjectivity of the observer. With the development of photography in the middle of the nineteenth century, the ability to fix camera images onto a material surface made this shift more evident. But photographs, as traces frozen in time, carry quite different connotations than projections that imply the immaterial and temporal. Jumping slightly with flickering light and always in anticipation of the movement of narrative sequence, projections have a spectral presence. They are ghosts of their subject. Favro exploits these qualities and the transparency of the medium to create a sense of real time and space. Typical of conceptual art of the 1970s, distinctions between taking and making, image and thing, are made visible.

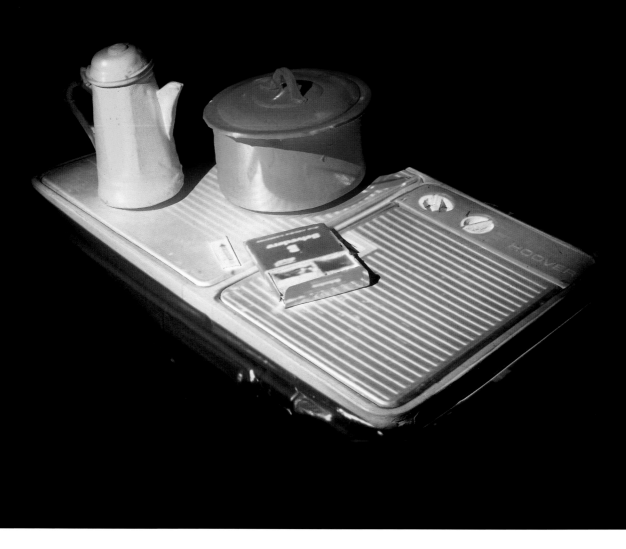

Favro's projected reconstructions unravel the technologies of illusion without losing the compelling realism of photographic illusion. Resembling very early photographs such as the solar writings of heliography, details are diffused in a luminous intensity. The elemental principle of shedding light on an object and more specifically, giving substance and materiality to form through projection is revealed. For example, in *Washing Machine* (1970) and *Still Life: The Table* (1970), three-dimensional mockups of objects covered with canvas painted white, are given definition by a wash of photographic detail from projected slides. As if painted with light, the shapes acquire material presence and identity. The mechanical eye of the projector thus functions as a type of prosthetic sense extension that gives life to the latent tableaux. Yet, as with any light-driven source, presence is only temporary and disappearance is imminent. What initially look like illustrations of science experiments are experienced as poetic metaphors for illumination as knowledge. Typical of optical devices,

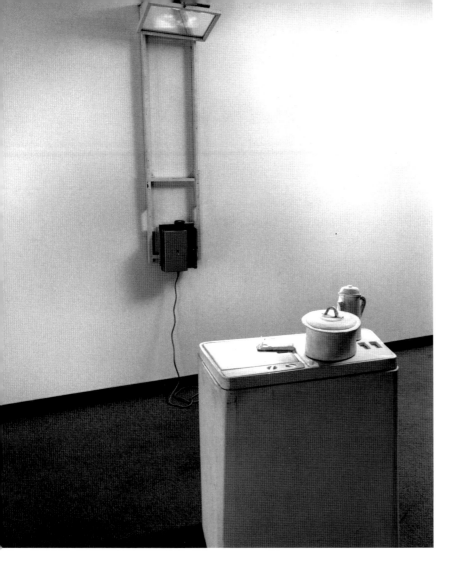

distinctions between picture and object, figure and ground, surface and depth are condensed, an effect that here is exaggerated by the presence of the observer standing literally in the illusion. These works resonate with a sense of instability, similar to the retinal hallucination created by an afterimage. Like virtual reality, the images seem to have no permanence beyond that of visual memory. Their effect is that of an aura, as Benjamin has described, "a strange web of time and space: the unique appearance of a distance, however close at hand."[4]

In addition to the inherent implications of making a model, the doubling of image and object sets up a dialogue between original and copy. Even though a reproduction, photography is still considered a realist form of representation par excellence, whereas in Favro's projected reconstructions it is obviously a simulation. The projected images appear as real as the modelled objects, both evidently facsimiles. Distinctions between things and their representation are thus made irrelevant. The fact that the artist's original source is already a

slide, another reproduction, amplifies the effect of several mediations. Any realism in Favro's reconstructions is that of illusory play revealed as artifice, even deception and trickery. Abstract form and realist image are fused in such a way that the observer becomes a complicit participant in the act of perceptual reconstruction. As with most of his sculptures, Favro makes no claim that illusion is anything other than a mechanical production, an effect that underscores the filtering process of mundane experience.

Issues of authenticity and reproduction become more intricate in *Van Gogh's Room* (1973-74), a sculptural replica based on a slide of a painting (already a representation) overlaid with a projection of the slide. Preconceptions of the famous original – Van Gogh's *La chambre de Van Gogh à Arles* of 1888 – are brought to bear on our experience of Favro's stage-set replica. The exaggerated perspective of Van Gogh's bedroom pulls the viewer into a vertiginous space that, in this version, becomes even more disorienting as Favro further stretches the already wonky perspective of the painting's attenuated space. The slide projection too, aside from adding Van Gogh's vivid colours to the objects and filling in the back wall, coats the scene with a bizarre cheeriness. Van Gogh's conflation of the real and imaginary, thus, becomes a more intensified dynamic in Favro's painting. Favro's can be experienced from several places in the room. In this sense, the artist appropriates Van Gogh's bedroom by inhabiting the room himself, as if taking it over will make it real. In the process of transforming this subjective space into a three-dimensional illusion, he comes to understand how depiction works, a typical exercise for Favro. As Marie Fleming has pointed out, "he is revealing modes of illusion as much as levels of reality, and, in so doing, providing an anatomy of disillusion."[5] This layering of mediations serves to deconstruct notions of "picture plane" and "visual field," highly contested concepts in the early seventies when this piece was produced. More importantly, though, *Van Gogh's Room* eclipses any conventional critique of painting by effectively liberating the image from the constraints of the modern painting tradition altogether.

Favro's *Studio Window* (1989) is a corollary to *Van Gogh's Room*. Also a place of dream and imagination, the artist's studio is associated with the projection of the unconscious. Two projectors, positioned as if in stereoscopic vision, flicker with slightly askew images playing against a flat wall. The tantalizing apparition of depth produced by stereoscopes is absent; instead, the image is constantly blurred, as if unable to focus. Characteristic of Favro's works, here interior space and exterior surface are folded into one another. The studio is seen simply as a window with debris on its sill. Hidden in the chaos of foliage outside the window is a reflection of the artist taking the photograph and a shadowy hydro pole (that later becomes a sculptural work). This window-on-the-world is nothing more than refracted and reflected surfaces that refer back to the interior realm, to reflection itself. In an attempt to see clearly and to overcome blinking repetition, the observer physically enacts the basic principles of observation.

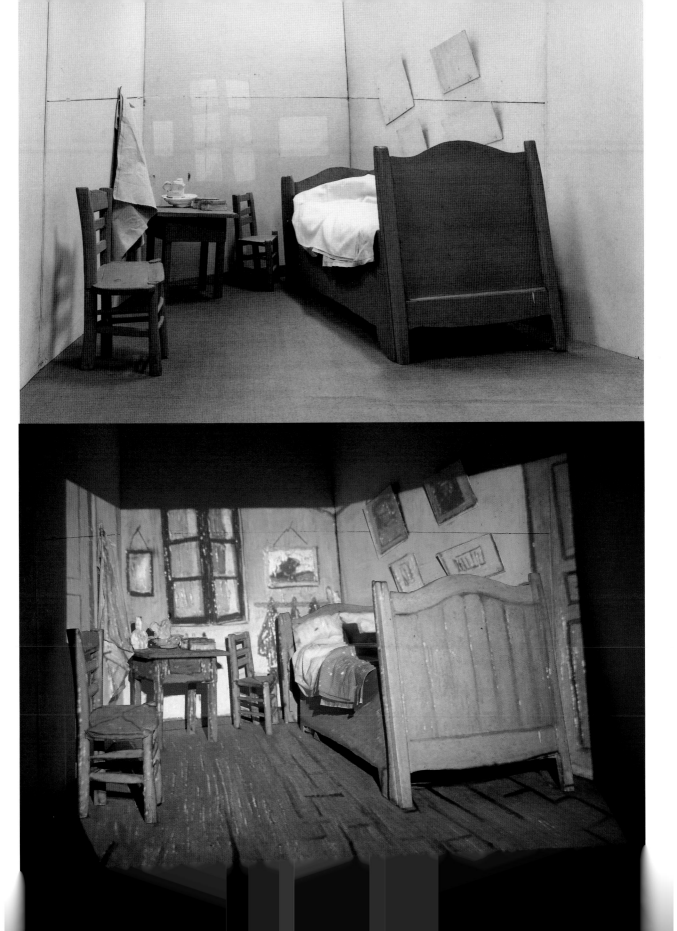

Still Life (The Table) 1970

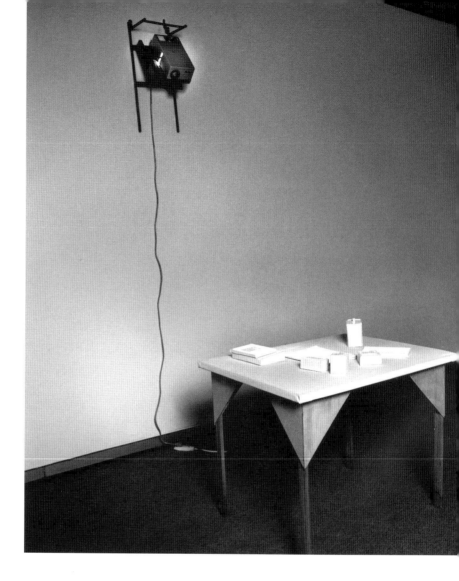

One of the artist's primary motivations is to decipher the world that he knows – his own backyard, so to speak. A respect for and curiosity about the commonplace things around him is evident not only in the use of salvaged scrap and generic materials but also, more importantly, in the type of objects he makes. They are culturally specific things from a particular time and place that carry the social meanings of everyday objects. The unadorned functional furniture of Van Gogh's rustic scene of domesticity, with all of its class connotations, reflects the artist's fondness for the generic and mundane. *Still Life (The Table)* for example is a display of personal work-related items on a simple table – a Unival battery, a Hammond transformer box, an ohmmeter, a variable resistor box, Marshall McLuhan's book *Understanding Media*, Franz Reuleaux's book, *The Kinematics of Machinery: Outlines of a Theory of Machines* and issue 219 of *Scientific American*. Impersonal commodities are

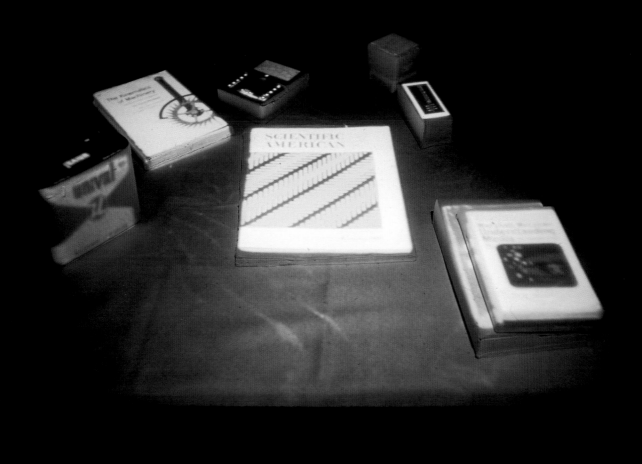

personalized in this vanitas self-portrait. A play on the genre of still life with its references to the aesthetics of consumption, the image of luxury presented here is that of knowledge, the essential food for an artist.

In *Washing Machine,* the *mise-en-scène* is also from daily life – a coffee pot, saucepan, pack of cigarettes and stick of gum casually placed on a washing machine. In a typical Favro inversion, this seemingly ad-hoc assemblage of mass-produced objects is actually the result of the labour-intensive precision of model making. A washing machine, like a computer today, is indicative of the contradictions of automation. While a time-saving and labour-saving convenience, what was once a communal activity is now done in isolation. Moreover, by making artwork a visible expression of a personal investment of time and labour, typical of the real-time, task-oriented art of the 1970s, the artist refers to the social conditions brought on by technological innovation. Aside from showing Favro's strong commitment

to workmanship itself, this piece considers how mass production has profoundly altered our understanding of work and and its relationship to creativity.

Favro's most recent projected reconstruction, *Bolex Camera* (1998), is a conceptually succinct comment on technologies of perception. An unpainted wooden replica of an old film projector is covered by a slide image of the same projector. From the front, the flat structure suggests a black and white photograph. The vision machine and its image become one, as if the projector cannot exist without projection. The attenuated gestalt perception of earlier projection works has now almost disappeared. A similar effect is created in several of Favro's recent sculptures that are painted to create the modelled effect of black and white photographs. As in other projection pieces, the slightly misaligned light creates an aura that makes the viewer conscious of sight. Both the subject and object of this work, projection here implies seeing and knowing as an act of reflection. Seeing machines do not simply produce fictions but, rather, are an essential tool for apprehending reality. Favro's projections are in the end phantasmagoric mini-spectacles – mechanical demonstrations of experiencing the world as an illusion of the world.

With the film projection pieces, time is a more dominant element than in the still lives, as narrative is implied in the very nature of the medium. In *Light Bulbs* (1970), oversized wooden lightbulbs are animated by a film sequence of constantly changing coloured lightbulbs. There is an absurdist quality to this non-narrative of mechanical repetition and its polkadot pattern of colours. Interestingly enough, nothing is actually moving in the film and the only narrative is that of duration. As with other film projection pieces such as *Synthetic Lake* (1972-73)*,* in which footage of moving water is projected on a wave machine, slippage between the mechanism and its projected image is nature describing itself.

Favro's quasi-scientific procedures for often seemingly absurd ends are nevertheless more reassuring than the hyperrealism and shadowy reality in the Platonic cave of advanced technology. His technical objects are products of an imagination that tries to make sense of mundane experience. As with many artists of his time concerned with expressing the inter-sections of art and everyday life, Favro has focused on articulating his relationship to the immediate environment as a physical and social place.[6] Favro looks to the prosaic, things that are so familiar and essential they are are no longer noticed. He asks what happens when we look again and see the same thing differently. While Favro's sculptures are immediately recognizable and familiar, as art objects in a museum – displaced in time, space and purpose – they seem like lost relics from material culture. As artifacts whose past functions still carry visual value they are now in a state of inertia, retrograde and somewhat abject. It is this sense of displacement that makes us look at them again, to decipher how things work.

Notes

1. "Murray Favro's Journal," *20 Cents Magazine* (May 1969), unpaginated.

2. The projection work, *Country Road* (1971-72), featured a replica of Favro's 1961 Corvair.

3. This gesture is similar to the preference for the medium of watercolour amongst many London artists.

4. Walter Benjamin, "Walter Benjamin's Short History of Photography," *Artforum* 15 (February 1977), 50.

5. Marie L. Fleming, *Murray Favro: A Retrospective* (Toronto: Art Gallery of Ontario, 1983), 74.

6. Favro's methodical investigations of place are in keeping with the many London artists who have had longstanding involvements with recording and measuring their surroundings. His works can be seen as directly related to such works as Greg Curnoe's *Device for Measuring London* of 1971.

THE GUITARS

Once I've finished a guitar and tested it it's already somewhat discarded. The experiment is over with, so it goes on the wall or I might play it for a while.

[Murray Favro, from *Noisemaker*, 1998]

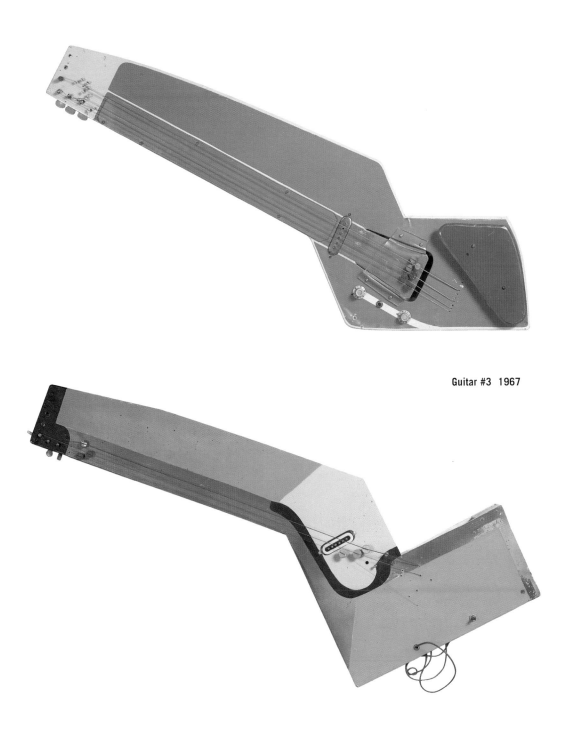

Guitar #3 1967

Guitar #1 1966

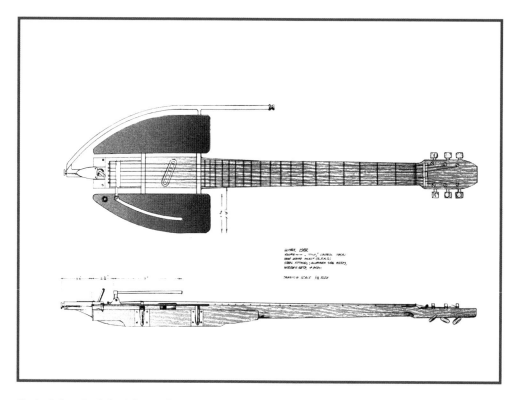

Music Gallery Portfolio: Guitar Design 1982

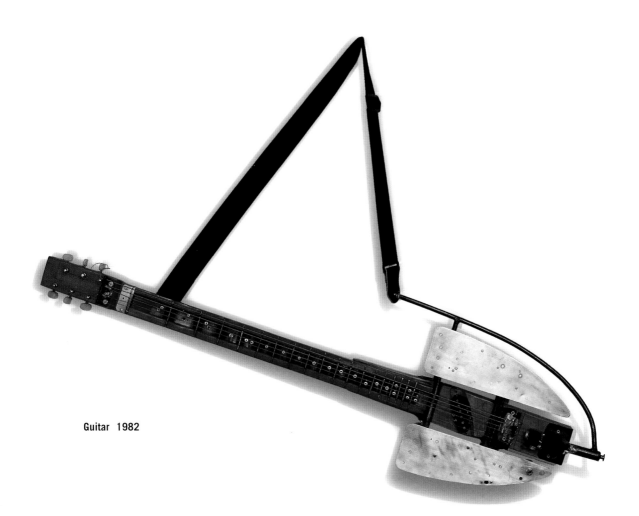

Guitar 1982

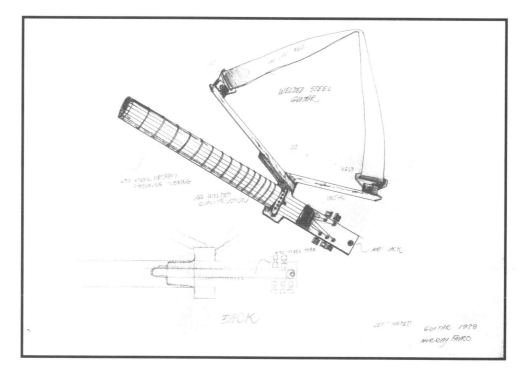

Study for Left-handed Guitar 1978

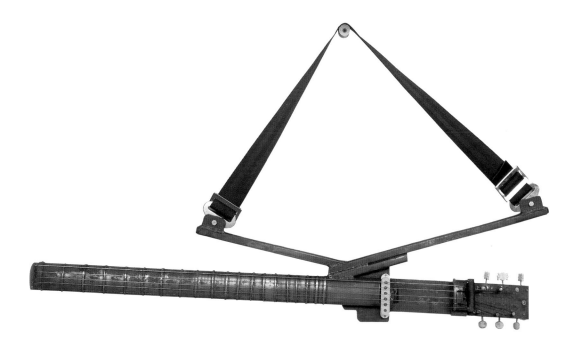

Welded Steel Guitar 1978

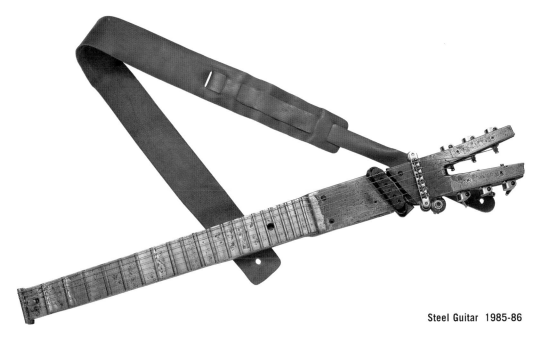

Steel Guitar 1985-86

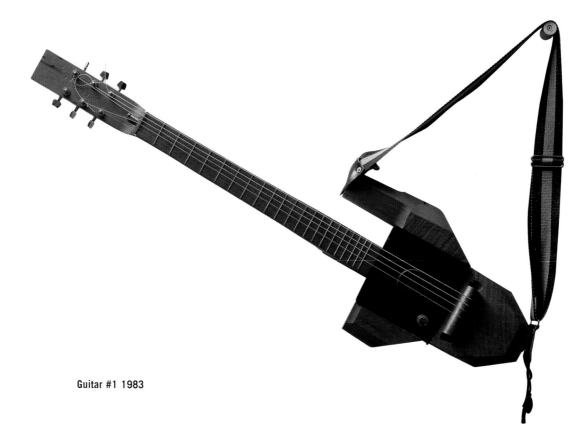

Guitar #1 1983

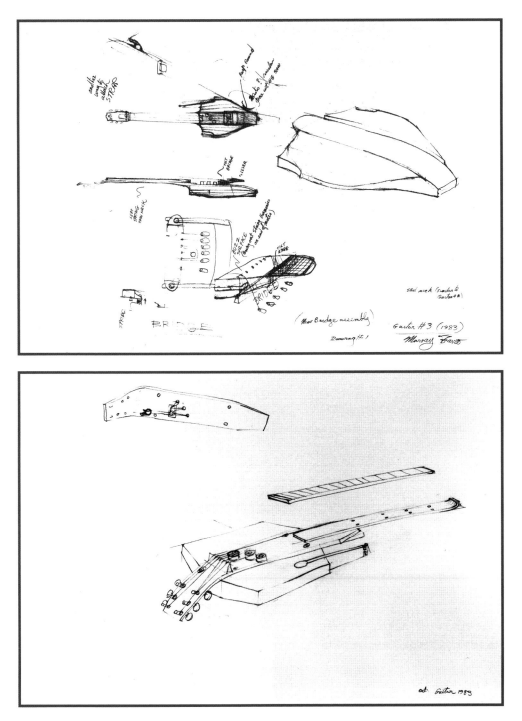

Study for Tilt Bridge Mechanism 1983

Study for Guitar 1983

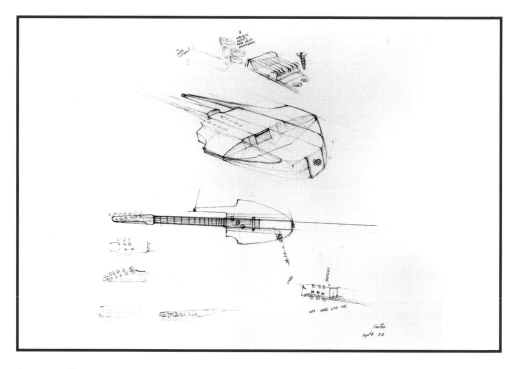

Study for Guitar 1982

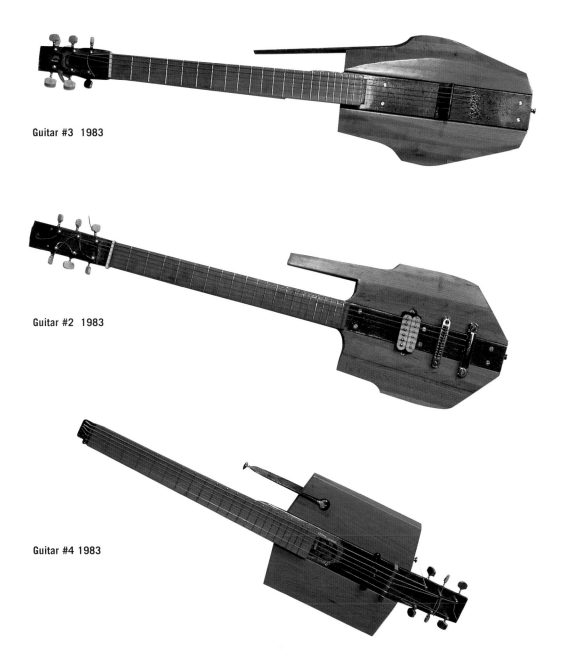

Guitar #3 1983

Guitar #2 1983

Guitar #4 1983

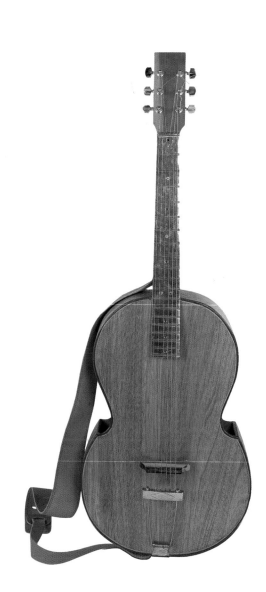

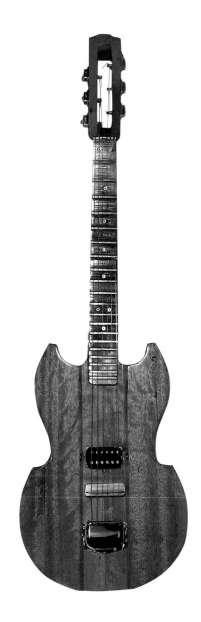

Acoustic Hollow Body Guitar 1988-89

Hollow Body Guitar #1 1987

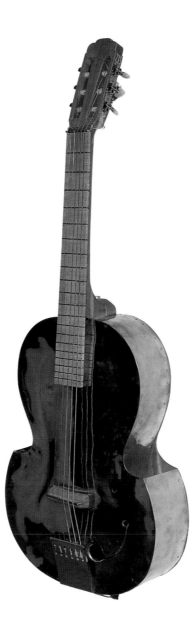

Brass Guitar 1993

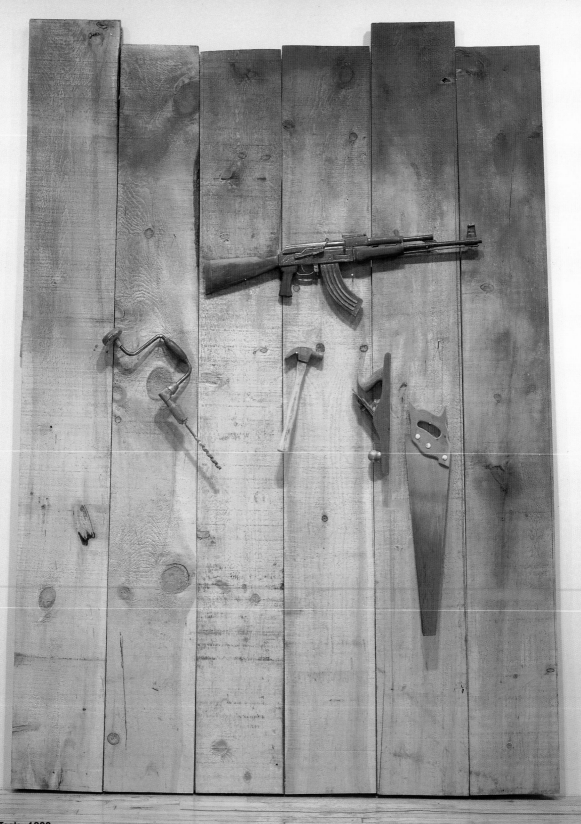

Tools 1998
Wood, metal, paint
251.5 × 185.4 × 12.7 cm
[not included in the exhibition]

HAND TOOLS

Robert Fones

EVERYONE HAS USED TOOLS – even scissors, knives and forks are tools – so you know how integrated they become with your body and with the work you are performing. Once you have acquired a certain degree of skill with a tool, you no longer have to think about it. Aside from fingernails and teeth – the body's own built-in tools – hand tools represent humans' first step in using things in the world to get tasks done. But our use of tools is so automatic that we rarely stop to analyze what we are doing or to ask how these labour-saving devices got into our hands.

During a recent summer visit to Nova Scotia I had an opportunity to observe a hand tool in use at a pioneer homestead called Ross Farm Museum. A cooper or barrel-maker used a curious, wooden, semi-circular plane called a "double-gear" to level the tops of assembled barrel staves. Then, he deftly flipped the double-gear over and ran it along the newly formed top edge to cut a V-shaped groove on the inside of the barrel to accommodate the flat, circular wooden top or "head."

What impressed me was that the curve of the double-gear exactly matched the circumference of the barrel. The tool and the barrel seemed inseparable. How could you make a barrel without this specialized plane? Conversely, why would a tool like the double-gear come to exist without a barrel-making industry already in place? It was hard to imagine one without the other.

I have always been interested in the history and evolution of hand tools and, because I had recently seen a group of new works by Murray Favro – a number of which incorporated hand tools – tools were on my mind as I watched the cooper. Three of these recent "tool" works – *Tools* (1998), *Wooden Anvil* (1997-98) and *Snow Plane* (1997-98) – are a continuation of the "painting sculptures,"[1] as Favro has called them, that he has been making since 1991. A fourth work, *Lever and Wheel* (1997-98), is a mechanical device that reflects Favro's interest in modified machines as represented by his guitars, bicycles, propellers, engines and turbines. All four works have a connection to industrial technology, a topic Favro explored in two preceding works, *Hydro Pole* and *Railroad Tracks*, both from 1995-96.

My initial impression on seeing these four works at Christopher Cutts Gallery in Toronto was that I had stepped into a pioneer museum and was looking at a display of nineteenth-century tools. There was an anvil sitting on a two-foot length of log with a hammer tucked into a steel hanging strap, a selection of woodworking tools displayed on a wall of vertical wood planks, and an old wooden ski mounted diagonally on the wall. There were two other objects that didn't quite fit into this pioneer scenario but their similarity to pieces of old farm machinery meant they also did not seem entirely incongruous.

The three tool pieces appear to consist of real tools. Once you get closer to them, however, it is obvious that they are, for the most part, carved out of wood and painted to simulate metal. It seems odd at first that Favro, who uses many hand tools to make his work, would make non-functional wooden tools. But it is probably his familiarity and experience with hand tools that led him to investigate them more fully.

Tools is the most museum-like of the three tool works and the most startling in its verisimilitude. It is a recreation of a photograph taken by Larry Towell of a wall of tools in Nicaragua. Once you are aware of the photographic source, you sense that you are stepping into a virtual space as you approach this work. It has the same supernatural quality as Favro's only other work to date based on a two-dimensional image, *Van Gogh's Room* (1973-74). Favro first saw the photograph at Larry Towell's sister's house and it stuck in his mind. With Towell's permission (Towell lived just outside London, Ontario, at the time), Favro recreated the photograph in three dimensions, meticulously reproducing each tool out of wood.

Tools resembles the wall of tools found in any number of small-town museums throughout North America. However, amidst this selection of woodworking tools that includes handsaw, brace and bit, plane and hammer, there is also a machine-gun. Its inclusion brings up a number of questions that must have also intrigued Favro and attracted him to this photograph in the first place. What does a machine gun have in common with woodworking tools? What kind of trade does the person who owns all these objects practise? Is a machine-gun a hand tool in the same sense as all the others? What is a tool?

The definition of "tool" is threefold: it is used by the hands; it is used in connection with a trade; and it performs some kind of work. Certainly, all the objects in *Tools* are used by the hands. This fact accounts for many similarities of form between one woodworking tool and another and between the tools and the gun. They all have wooden and metal parts, places for the hands to engage (*handles*) and specific parts – teeth, cutting edges, bullets – that constitute the working elements.

The close association of tools with the hands and the human body is reflected in the names of various tool parts. The hammer, saw, brace and plane all have *handles* where they are gripped by the hands. The hammer has a *head*; the saw has *teeth, heel* and *toe*, the brace has *jaws* and the plane has a *toe, heel, sole* and *mouth*. Significantly, the machine gun, even though it is held in the hands, does not have this same repertoire of

body-part names. Has its more recent invention not given it enough time to develop a close association with the body?

Except for the machine-gun, all the tools in *Tools* are associated with one trade: woodworking. Woodworkers use tools. Plumbers use tools. Mechanics use tools. Even the features in many computer applications that are used to manipulate selected items are called tools. But hockey players use equipment. Doctors use instruments. Soldiers use weapons. There is a distinction between the tools used by a trade and tools used by a profession that has its roots in the social structure of medieval Europe. Someone learning a trade would become an apprentice within a guild. A doctor would learn the profession by academic study. How do weapons fit into this system? Do the woodworking tools and gun represent a single trade in any sense of the term?

The gun was of course a vital component of every American pioneer's survival kit, both for hunting and defence. But it was never traditionally hung with woodworking tools; it may have hung above the mantelpiece or leaned beside the front door. While a machine-gun may be an essential tool for a Nicaraguan worker, its inclusion with woodworking tools is unconventional. Furthermore, a machine gun is not the traditional pioneer firearm. It is associated with criminals, mob violence, terrorism and warfare. Its inclusion in the tool group undermines a nostalgic perception of pioneer life, suggesting instead the grittier reality of establishing, keeping and protecting a homestead or parcel of land in the unstable political climate of Nicaragua.

The ubiquity of both hand guns and hand tools today is in part due to a method of nineteenth-century mass-production that had its origin in the United States: the standardization of parts, and the resulting interchangeability of those parts. This method of manufacture – first used by Eli Whitney in 1798 to produce sets of arms consisting of muskets, bayonets, wipers, ramrods and screwdrivers – assured the buyer of a particular tool that all the versions of that tool would be identical and that replacement parts would always be available and would fit easily into an existing tool.

More importantly, the standardization and interchangeability of parts in American manufacturing fed into the expansionist ethic of Manifest Destiny; the continent could be more easily invaded, settled and exploited if guns and tools could always be repaired with replacement parts available from outpost suppliers. This applied equally to farm machinery, wagons, locks and eventually to appliances and automobiles, all of which adopted the same system of manufacture. Any automaker today knows you cannot sell cars without provid-ing a support system of parts suppliers and service centres to repair them.

This imperialist manufacturing ethic is not confined to the United States alone. It has infiltrated other countries as well, particularly those in competition with the United States and those that emulate the American model. Consequently, it is not surprising to find American-made hand tools and a Russian-made machine-gun hanging side by side on a

worker's shed wall in Nicaragua. Nicaragua is a country torn by civil war but it is still consistently supplied with the tools of both industry and war by two major industrial giants. It is not surprising to find hand tools that have become, for the most part, obsolete in the United States, turning up in less industrially advanced countries where they still have significant value.

The machine-gun bears a striking resemblance to another of Favro's long-time obsessions, the electric guitar, another American invention that has proliferated around the globe. Both are held by two hands, make a loud noise and can assault an enemy or an audience from a distance. Favro's all-metal guitars in particular look quite deadly and straddle a fine line between musical instrument and weapon. The similarities between a guitar and a machine-gun underlines the fact that technological advances are often applied to weapons as well as more benevolent inventions.

To translate Towell's two-dimensional photograph into three dimensions Favro had to carry out research into each tool and examine all its component parts. Some tools, such as the handsaw, were generic enough that Favro could use his own woodworking tools as models. Others, like the machine-gun, required more extensive research. Except for the crank of the brace, all the tools are made of wood. The elongated nature of the crank and its complicated bends defeated Favro's efforts to make it out of wood. Instead, he simply bent a piece of metal rod into the desired shape. This practical act confuses the distinction between real and fake, enhancing the illusionism of this work.

In *Tools* Favro has striven for a provisional simulation of reality. The illusion is absolutely convincing as you approach this work. Then at a critical threshold of five or six feet, the effect vanishes as the real materiality becomes apparent: the blade of the handsaw is only painted plywood, the drill bit is carved wood! In his book, *Looking at the Overlooked,* Norman Bryson explains the effect of *trompe l'œil*: "For the split second when *trompe l'œil* releases its effect, it induces a feeling of vertigo or shock: it is as if we were seeing the appearance the world might have without a subject there to perceive it, the world minus human consciousness, the look of the world before our entry into it or after our departure from it."[2] The illusion in these works is only as resolved as any theatrical prop – whatever is needed to create a convincing illusion of reality from a certain viewing distance. In the case of theatrical props, the illusion is maintained because the viewer cannot walk on stage for a closer look. In Favro's work, closer inspection is possible.

The evaporation of the mirage is not a disappointment. What replaces it is a new kind of perception, a sense of peeking behind the scenes into the structure and meaning of tool design. In these models, the complexity and ingenuity of each tool becomes much more evident. Favro reverts the machine-made to the model that often precedes mass production. (Samuel Colt made a crude wooden model before manufacturing his first hand-gun.) By remaking all these tools out of wood, Favro separates the function from the form and allows the viewer to contemplate the latter in isolation.

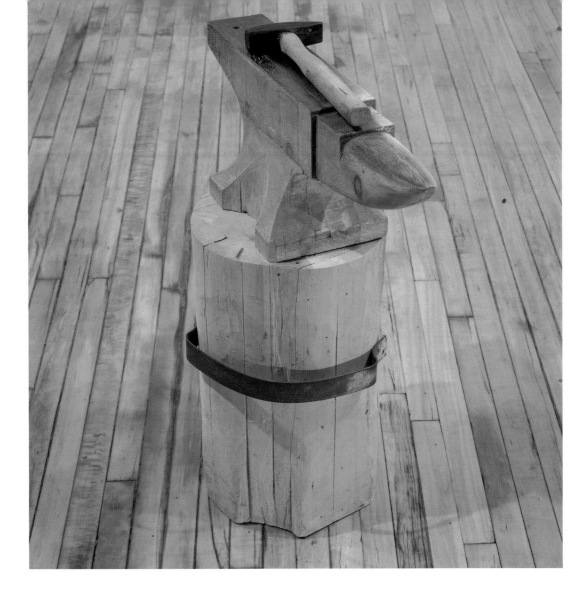

Like *Tools*, *Wooden Anvil* appears to have emerged straight out of our recent colonial past. The anvil is poised on a section of log. A hammer is tucked into a metal strap attached to the log. This ensemble evokes the traditional blacksmith's trade and seems to await the return of the black-smith to resume his work. In fact, *Wooden Anvil* is a reconstruction of an anvil Favro has used for years. I had never really looked closely at an anvil until Favro made this one out of wood. As with *Tools* the transformation from one material to another isolates the form so that it can be more easily studied, free of its normal associations of handicraft, pioneer life or a senti-mentalized past. Favro's *Wooden Anvil* is consequently a meditation on an

Wooden Anvil 1997-98

Snow on Steps 1994

obsolete economy as well as a model for contemplating the forms of the tools used in a particular trade. It is this timeless quality that makes *Wooden Anvil* so mysterious and engaging.

In spite of its evocation of a handicraft tradition, *Wooden Anvil* manages to escape an aura of nostalgia. Partly, this is the result of Favro's decision to stop his recreation short of verisimilitude: knots show through the metal patina and painted colouring of the anvil and hammer; glued joints are visible in the log. Favro's method of finishing these works by rubbing them with oil colours and powdered graphite creates a transitory effect quite different from the painted realism of *Snow on Steps* (1994) and the other "painting sculptures."

There are degrees of illusionism in *Wooden Anvil*. The handle of the carved hammer is the least deceptive since both its form and material mimics that of the original handle. The log section supporting the anvil in this work is made of wood even though it is carved and not an actual log. Even the knots on the log seem natural because they appear where real knots might occur; but the glued joints of the laminated block from which the log was carved reveal Favro's artifice. Finally, the sight of knots showing through the slightly metallic veil that covers the anvil is definitely incongruous. As in *Tools*, the replacement of one material by another within an object's given form, separates the function of the object from its form allowing a more objective consideration of both.

The anvil's transformation from iron to wood creates an uncanny effect, as if the log section had returned to life and grown up through the anvil, replacing its molecular iron structure with wood. This organic quality gives the anvil the character of a living form, and permits its curious design to be seen as the result of an evolution in response not to environmental factors but to technological, economical and social ones.

The anvil has a *tail*, *beak* or *horn* and *feet*, names suggestive of animal rather than human anatomy. Indeed, it is a kind of beast of burden since it is really a workbench for making tools rather than a tool itself. As with any animal, each feature of the anvil has a unique purpose or exists for a specific reason. The anvil's horn is used for shaping curved metal pieces; its tapering form accommodates curves of different circumference. The splayed feet of the anvil gives it greater stability and allows nails to be positioned to secure it to the log section on which it sits. A rectangular steel face – much harder than the wrought iron of the body of the anvil – was normally welded to the top of the anvil, which accounts for the half to one-inch drop from the *face* to the *table*, the ledge slightly below the main surface of the anvil.

Even the holes in the top of the anvil have names and functions: the *pritchel* hole is round and is used as a recess for punching holes in metal strips; the square *hardie* hole is used for holding various shaping and cutting tools, all of which have a square peg that fits into the hardie hole. As with most tools (and most animals) the anvil has no extraneous parts and is simply material formed to meet a specific need.

But the anvil in *Wooden Anvil* is not alone. It sits up on a section of log that raises it to convenient working height. A third companion is the cross-pein hammer. For thousands of years these three objects have formed the blacksmith's basic toolkit. Aside from elevating the anvil to a good working height, the log provides a convenient place for attaching the steel strip that serves as a holster for the hammer and also serves to dampen the vibrations of metal on metal. In spite of dramatic technological developments in the steelmaking industry, the blacksmith's toolkit has survived virtually unchanged up to the present. The blacksmithing trade, however, has diminished considerably since the introduction of the automobile, which all but eliminated the blacksmith's role of shoeing

horses. But the anvil, old workhorse that it is, still provides faithful service to Favro and other practitioners of small handicraft like him.

If the anvil has had an illustrious evolution out of the blacksmith's hearth and up on to a log where it perches like a faithful pet, the other object in Favro's tool room is a mutant or hybrid with a less noble pedigree. *Snow Plane* is a conjunction of two found objects: part of an old Stanley woodworking plane and a single wooden ski. The resulting object is slightly surreal and yet entirely plausible. Could this "tool" be worn on the foot to flatten a wooden floor by skiing across it? Could the plane be used by hand to smooth extremely long boards? Could a snow-covered field be levelled by skiing back and forth across it? The idea of someone planing snow by skiing across it may seem ludicrous, but the image of it is striking and emphasizes the technological novelty of both planing and skiing. *Snow Plane* also provokes speculation about the morphological evolution of both skis and planes, about the similarities between their function, and the cultural distinction between objects used for work and objects used for play.

Snow Plane is surprizing because it is, I believe, the first time Favro has created a surreal object. It is reminiscent of Man Ray's *Gift*, a flatiron with a row of tacks on the bottom. Like *Gift*, *Snow Plane* is a serendipitous and humourous conjunction of two objects with two different functions. Both works provoke speculation about their functionality and meaning. By inserting a row of tacks that would shred fabric rather than smooth out wrinkles Man Ray negates the flatiron's ability to function; at the same time, the tacks playfully suggest the steam jets of modern irons that would eventually make flatirons obsolete. Unlike Man Ray's flatiron, *Snow Plane* could theoretically function. However, since the plane's cutter is only wood (it was missing from the beginning and Favro had to make a substitute), Favro is clearly more interested in imaginative speculation than actual use.

This conjunction of ski and plane could not have occurred if Favro had not acquired a plane at a particular stage in its evolution. The plane in *Snow Plane* (an old Stanley plane designed by Leonard Bailey in 1867) is halfway between the old all-wooden planes and the modern all-metal ones; it has a wooden sole and a metal body. Consequently, Favro was able to remove the cast iron part and mount it on a single ski. The downhill ski was originally painted black, but Favro sanded it down to bare wood and made it look older by darkening its ends with graphite. The aged look is more compatible with the older style of plane while the bare wood echoes the appearance of the original wooden sole. In linking these two objects, Favro may have been unconsciously influenced by the morphological similarity between a plane and a foot. (A plane does have a *heel*, *toe* and *sole*.)

While the conjoined objects spawn a new hybrid invention that is not immediately useful or practical, it does generate interesting speculation about its possible application and about the similarities between the creative and inventive process. Conjunction – a common occurrence in design evolution—results when two devices with

Snow Plane 1997-98

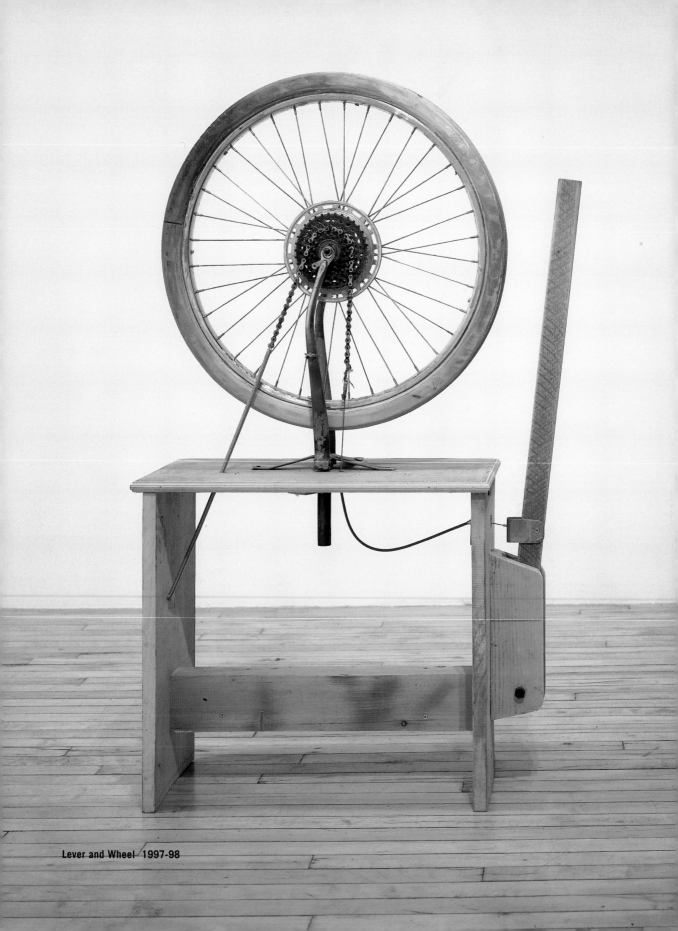

Lever and Wheel 1997-98

parallel development suddenly merge to form a new invention. The fusion of typewriter and television in our own computers is a perfect example. One would not expect skis[3] and planes[4] to cross paths, but at some point in their evolution the two would have met since planes would have been used to prepare the strips of wood for making skis. Eventually this task would have been taken over by the electric jointer – essentially a huge plane turned upside down, motorized and mounted on the floor. The plane that is integrated into *Snow Plane* is consequently symbolic of the tool used to make wooden skis. This conceptual irony reflects the nature of tool development, since existing tools are often used to make new tools as well as copies of themselves.

The title, *Snow Plane,* rather than being simply descriptive of the two conjoined objects (Favro could have called it *Ski Plane*), suggests that *Snow Plane* could be used for planing snow. Other conjoined objects have produced useful devices: ski planes, snowplows and snowmobiles. *Snow Plane* is an example of the many inventions that have been ignored, shelved or abandoned because they didn't have an immediate application. However, *Snow Plane* epitomizes that spontaneous and irrational impulse that so often leads to the great breakthrough inventions. *Snow Plane* has another positive effect: like the machine-gun mixed in with the woodworking tools, *Snow Plane* sends a mixed signal, prompting a re-evaluation of our society's division between work and sports, labour and play.

As if to further pursue the question of what constitutes a tool, Favro exhibited another work with the three I have been discussing entitled *Lever and Wheel*, which does not appear to be a familiar or recognizable tool. It looks like a mechanized version of Marcel Duchamp's famous bicycle wheel. It is crudely constructed out of wood but the rim, spokes and axle are from an actual bicycle wheel.

Duchamp's wheel was turned by spinning it with a finger. Favro has given himself the task of mechanizing this operation. *Lever and Wheel* has a handle that pulls on a short section of bicycle chain that in turn engages with the sprocket of the bicycle wheel. By pulling on the lever, the wheel can be made to rotate. By repeatedly pulling the lever, the speed of the wheel can be increased.

Unlike the hand tools in the other three works whose function must be conceptualized or conjectured, this device can be activated. Pulling the lever is as addictive as cranking the arm of a slot machine. The reward is not spinning lemons or quick cash but the hypnotic spin of the bicycle wheel, obviously as mesmerizing for Favro as it was for Duchamp. And the effort expended seems so slight, compared with the rapid acceleration of the wheel. Herein lies the technological wonder of this work.

Lever and Wheel demonstrates the effectiveness of the lever[5] in concentrating and transmitting effort. If you have ever tried to move a large boulder by sticking a smaller rock beside it and pushing down on a long pole wedged between the two, you have used the principle of the lever. The lever in this work is pinned at one end and connected to a wire

cable that connects with the bicycle chain, bicycle sprocket and wheel.[6] By placing the handle furthest from the pivot point, Favro causes the applied effort to be transferred more efficiently to the wheel. A simple spring returns the lever back to the starting position.

The wheel would not continue rotating quite so easily if Favro had not increased its weight by replacing the inflated tire with a solid wooden one. This extra weight at the rim turns the bicycle wheel into a sort of flywheel, conserving energy and maintaining the wheel's momentum. From the sawdust remaining on the spokes and axle it is obvious that Favro used his device as a lathe to sand the wooden tire to its final desired shape. This fact makes *Lever and Wheel* a functional tool because it was used to perform work. The irony is that the turned wooden tire is now an integral part of the machine and so the ability of *Lever and Wheel* to perform additional work is negated.

However it still *works* mechanically, just as an idling car engine works even though the car is not moving. Without the active involvement of a participant as a source of power, though, the device cannot operate. Once someone grasps the lever and pulls it back and forth, they become connected to the machine as an integral part of its operation, their arm functioning as an additional jointed lever to provide the motive power.[7]

Having experienced this mechanical principle in operation, one can look at the hand tools in *Tools*, *Wooden Anvil* and *Snow Plane* in a new light, recognizing their relationship with the body, their reliance on us for their source of power and their similarities with and differences from our own bodies. The crank handle of the brace and bit, for example, while bearing some resemblance to the jointed structure of the human arm, does what the arm cannot do: rotate in a complete circle. The two- or three-jaw chuck that holds the drill bit is the equivalent of fingers. But unlike human fingers, this mechanical part never tires.

All of the five classical mechanical principles are at work here. The handle of the hammer acts as a lever with its pivoting point where it is grasped by the hand, thereby increasing the hammer's striking force. (Imagine trying to hammer a nail by holding only the head of the hammer in your hand.) The wedge is concealed in the cutting edge of the plane and in the teeth of the handsaw. The screw is there in the drill bit, in the bolt holding the plane mechanism together and hidden in several other places, holding various parts together. Hand tools would be useless without these primary mechanical devices.

Favro's reconstructed tools instill an appreciation for the ingenuity and complexity of these seemingly simple principles and the devices built around them. By making hand tools by hand, Favro removes the anonymity of mass-produced objects and makes them singular, worthy of the attention accorded any handmade object. He revives the tool-making process that started the long evolution toward industrial technology. These tools are part of his continuing investigation of mechanisms that extend the scope of human activity: bicycles, guitars, airplanes, trains, even perception.

Notes

1. The "painting sculptures" are life-size reconstructions of tableaux from Favro's own experience, usually scenes that are close to his home or studio. They resemble stage sets insofar as they have unfinished backs, recreate only portions of larger structures and are painted to simulate the real objects.

2. Norman Bryson, *Looking at the Overlooked: Four Essays on Still Life Painting* (Cambridge: Harvard University Press, 1990).

3. The earliest evidence of skis is found in a petroglyph of a curious rabbit-eared or horned figure on skis from Rødøy, Norway, dated around 2500 B.C. Wooden skis from this same period have been recovered from bogs in Sweden and Denmark.

4. Although the ancient Greeks had a word for plane, actual specimens do not appear until Roman times. The earliest examples are from Pompeii and hence date from shortly before the eruption of Vesuvius in 79 A.D. Pliny the Elder, who died while trying to observe this eruption, mentions the plane inadvertently when he discusses the wood of the fir tree: "The shavings of this wood, when briskly planed, curl up in circles like the tendrils of the vine."

5. The lever and wheel are two of the five primary mechanical devices (sometimes referred to as the "mighty five") identified by Archimedes in the second century B.C. The other three are the inclined plane, the wedge and the screw. Archimedes considered the wheel as a special case of lever because, like the lever, it rotates about a fixed point or axle.

6. In his discussion of the common grindstone, Franz Reuleaux – whose book *The Kinematics of Machinery* appears in Favro's 1970 work, *Still Life (The Table)* – notes that the stone could be kept in motion by methods other than a foot treadle: "If the workman held one end of a cord attached to the crank-pin he could easily, by periodic pulls or jerks, keep the stone in motion."

7. As Reuleaux states, "the body of the worker becomes kinematically chained with the machine." Franz Reuleaux, *The Kinematics of Machinery: Outline of a Theory of Machines*, translated and edited by B. W. Alexander and C. E. Kennedy (New York: Dover Publications, Inc., 1963; first published 1876).

Air Compressor and Turbine 1996-97

MURRAY FAVRO

TECHNOLOGY; PERSPECTIVE; THE EVERYDAY

Peter White

It's a....hunk of wood with a slide projection of a movie camera on it! Hah! Murray rocks.
(from a review of *Bolex Camera* [1998])[1]

THE COMMENT ABOVE notwithstanding, there is a decided preoccupation in the literature on Murray Favro's art with how difficult it is to say what it is or even write about. This seems to be true whether coming from a visual arts or more general perspective and whether the writer is favourably disposed to the work or not.

The problem, or confusion, has gone something like: it's definitely art because the context is art and he thinks of himself as an artist; his work is recognized as sculpture even though it often bears a striking likeness or refers directly to common mechanical devices (bicycles, airplanes, trains); or, in the case of the projections, they seem like they could be science experiments; or, with the guitars, they are shown as sculpture but are also actual functioning objects. At the same time, further uncertainty arises from the paradox that for all of their detail his sculptures seem like relatively simple objects and yet despite this simplicity it appears they could be incredibly complicated conceptually.

There is a circularity to this thinking in that the imprimatur of art is conferred on the work by its very elusiveness or seeming difficulty. Favro tends to reinforce these readings himself which, in effect, also underline his independence or distinctiveness as an artist. In a recent interview, for example, he took particular relish in discussing a singer from Mongolia who, when asked, rejected associations with any kind of movement or affiliation. "She wanted full credit for what she did." Moreover, "she didn't answer the questions that she was asked. She could pick out what a person was like by their question and answered the person, not the question."[2]

The desire to avoid being pigeon-holed, categorized or to be held to orthodox expectations is a view that in an "anti-art" strain of modernism has sanctioned "non-art" as art. There are decidedly Dadaist overtones here. Indeed, the critical context that

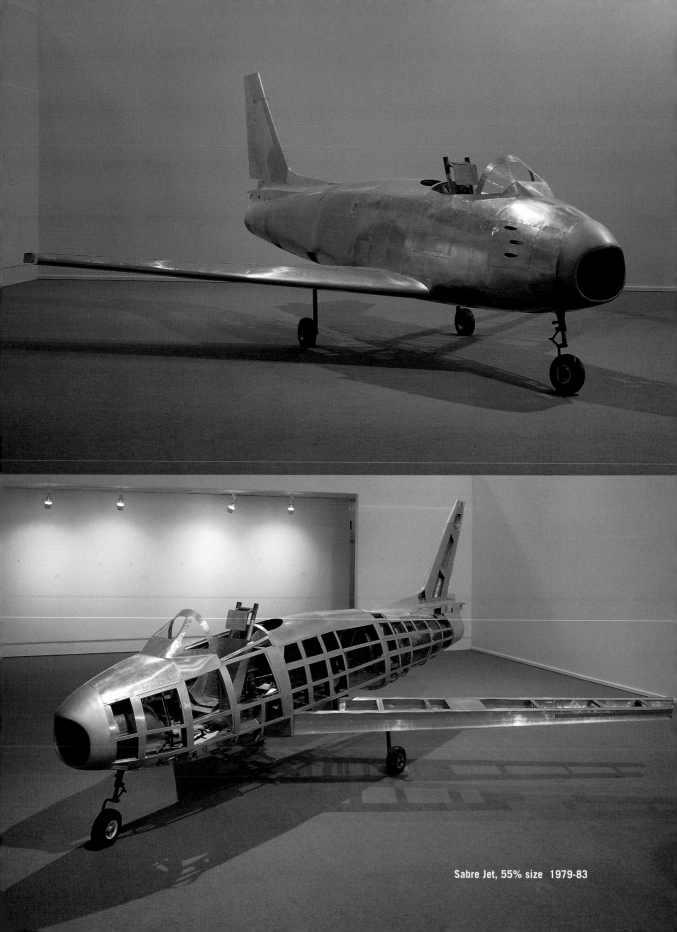

Sabre Jet, 55% size 1979-83

informs this standpoint is the modernist experience of questioning or upsetting conventional understandings of reality. It is a context in this century that encompasses not only the anti-humanism of Duchamp but also the utopian projects of the Constructivists and, closer to Favro's formative years in the 1960s, art and theory that sought to break down barriers between art and other human activities, be it Marshall McLuhan's communications theories, aspects of Pop art, John Cage's investigations of sound or Experiments in Art and Technology's attempts to reconcile art and industrial technology.[3]

This brief overview is not intended to suggest that this approach to Favro's art is not relevant or to imply that his work has not been formed or isn't firmly entrenched within modernism. It is intended, however, to consider the possibility that if there have been certain limitations in dealing with his art, then these may have something to do with preoccupations, dear to modernism, of essence and definition. Indeed, if it seems that Favro's work has been the subject of a naming whose very impossibility has produced an elusiveness that is the stamp of art, then the question is raised whether some approach other than naming might be in order. This too Favro has hinted at. In the same interview cited above, he speaks of applying paint to a sculpture to a point where it is "between being a wooden thing and a real thing. Right in there is somewhere where your imagination works." Not merely a space of indeterminacy, this is a place latent with multiple or manifold locations. The following considers a few of these.

Technology

Technology has always figured prominently in Favro's art. Flight was the subject of some of his earliest paintings and when he began to make sculpture, they too were about aviation: ornithopters, propeller devices, adaptive models of the Flying Flea and Sabre Jet. In recent years his subjects have been earthbound, but no less intriguing: rear pedal bicycles, mock railway tracks and a full-scale wooden version of a diesel train engine. The two latter sculptures were constructed as if rendered in linear perspective. A leitmotif of much of Favro's production has been energy and the transformations it generates. He has made models for air compressors, turbines and various other engines, re-created a hydro pole (in partial perspective), and developed functioning devices driven by electricity including electric windmills and guitars. The projections themselves have involved considerations of the transmission of light, cameras and image projection. While not highly focused in his work on the revolution in digital technology, Favro has been working with computers since he was introduced to the original mainframe at the University of Western Ontario in London by John Hart in 1969. With a recent series of hand tools, his perambulations in technology have taken yet another intriguing turn.

Favro's interest in technology invokes a number of venerable artistic traditions. One is the notion of the artist-engineer, a convention associated with Leonardo da Vinci, whose fascination with flight and flying machines Favro's ornithopter cites directly. The scientific method and attitude identified with Leonardo is clearly evident in Favro's work. It is perhaps most obvious in the often extensive working drawings and diagrams that are produced in the course of developing a sculpture, but is also there in a certain sense of authenticity on which he is insistent. The issue for Favro is not whether a particular idea will make the transition from the drawing board of art and speculation to the practical world, but that the methodology he has followed could yield such a result. In this sense it is immaterial whether his work is functional, a model, invention or innovation.

Favro's work refers to another tradition by default: the powerful anti-machine bias embedded in modernity. Along with great approbation, as well as varying degrees of ambiguity and unease, there have been constant feelings of hostility directed towards technology since the Industrial Revolution. This has been due in large measure to fears that people will be displaced, if not enslaved, by the machines that were going to liberate them. With the nineteenth-century rise of romantic individualism, these feelings have been experienced with particular animus in high culture, where creativity and subjective perception have been understood to be at stake. In this context, most attempts to bridge the gap between art and technology have resulted in either disappointment and failure, such as EAT, or the branding of these concerns as utopian and/or aesthetic and their absorption back into the category of Art. Examples of the latter include William Morris and the Arts and Crafts movement or the idealist modern design aesthetics of the Bauhaus.

For his part, Favro had been exploring his interest in mechanical devices in his art when he and several other London artists were invited to work with the computer by Hart. In the spirit of the time, Hart, who was head of the Computer Science Department at Western, seems to have been motivated by what he felt might be the creative possibilities of the then new and relatively unexplored technology. However, in a broader context, he was concerned with the negative position of applied science or what he termed the "practical arts" in relationship to pure science. In connection with this, Hart was actively developing and promoting a science of machines that he termed "mechanology."[4]

Little of a concrete nature came out of Favro's interaction with Hart. In retrospect, however, Hart's distinction between science and the practical arts is very relevant in terms of the two traditions to which Favro's work has been related. Distinctions of this kind are part of the modernist pattern not only of separating human activity into highly rationalized, discrete areas of specialization, but also assigning value to them on a comparative, hierarchical basis. In wanting to reposition or legitimize the machine as a science, Hart in effect was railing against a differentiation and bias that dates at least to Galileo's study of

Hydro Pole 1995-96

mechanics at the dawn of modernity in the seventeenth century. While Galileo recognized the ability of craftsmen to make mechanical devices, for example, he argued what they did wasn't truly scientific because, lacking a knowledge of mathematics, they could not develop their results theoretically.[5] As the Canadian experimental physicist Ursula Franklin has noted in a related context, this means that someone can go to university to learn to build a bridge from someone who has never built one.[6] In this sense, Leonardo's merging of art, science, engineering and philosophy doesn't so much herald the modern epoch as it represents the culmination of an earlier one. Moreover, given the prohibitions against technology, it is not difficult to see how efforts to deal with it from the perspective of art have been so easily rationalized away.

Despite his openness to interdisciplinary approaches, Hart's position was tenuous because his desire for change did not address the structure of specialization and opposition that frame his concerns. Like other modernist oppositions – form/function, mind/body, nature/culture, high art/popular culture, art/craft, etc. – the distinction between pure and applied science was so deep rooted that attempting to ameliorate the lesser term by inflecting it in the direction of the other one inevitably only has the effect of further entrenching the already privileged term. In these circumstances, it is hardly surprising that Hart's efforts did not prove more fruitful at the time.

Favro's practice, on the other hand, has not been shadowed by such problems. His work has never made claims as theory or science in an academic sense. It has always been secure as art and, despite the extent of his interest in the subject, does not seem to actively take a position on technology. Jockeying his work into the contentious pro and con dynamics that have characterized modernist discourse on technology seems irrelevant. Nevertheless, this is not to say his practice lacks a perspective on the subject. Quite the contrary.

The prominence of technology in Favro's work is interesting in that little of it refers to or is about leading edge technologies or the notions of progress they imply. When he began building his first Sabre Jet in 1965,[7] for instance, it was already a somewhat dated machine. And from there, he moved backwards in the history of flying machines. Indeed, with its interest in historic transportation and energy-related technologies, the point of reference of Favro's work, materially and emotionally, would seem to be a somewhat reflective one notionally linked to the world produced by the Industrial Revolution.

It was not just the steam engines, trains and other technologies associated with the Industrial Revolution that aroused such a wide range of feeling and opinion about machines. Rather, it was the vast changes in the organization and nature of both work and life to which they were so intimately related. Of these, the division of labour and increasing social stratification and fragmentation based on class are perhaps the two most fundamental.[8] In a study she titled "The Real World of Technology," Franklin has

characterized technology not as a set of procedures or hardware but an all-encompassing practice of interrelated knowledge, activities and structures. She understands technology as a system that produces institutions and re-orders social relations to meet the very needs and desires it engenders. It is not only self-fulfilling but also highly ideological. Referring to the Industrial Revolution, Franklin cites the enormous ramifications of the power of technology to organize or, quoting Foucault, discipline life according to its own prerogatives of efficiency and rationality as if this were somehow right, just or inevitable.[9]

Franklin uses the term "prescriptive" to describe the large-scale, product-centred technologies that have been predominant since the Industrial Revolution. Requiring external management and control together with complex administrative and distribution infrastructures, they demand specialization by process and involve little or no context in terms of social relationships, needs or effects. Because they limit workers' skills and autonomy, prescriptive technologies also involve high degrees of conformity. "These prescriptive technologies that now encompass almost all of technological activity are, in social terms, designs for compliance," Franklin writes, "and in this I find one of the most important links between technology, society, and culture."[10]

In contrast to these profoundly modernist technologies, Franklin refers to technologies she describes as "holistic." Associated with the notion of craft, in these technologies the individual worker remains in control of the processes of production. Whereas experience and knowledge are separated or opposed in prescriptive technologies, here they work together. Such technologies are largely pre-modern and pre-industrial, but it would be doing a disservice to the profoundly progressive, even transgressive nature of Franklin's ideas to suggest she herself has fallen into a modernist trap, reiterating on a broader social scale a desire for something like a return to crafts and hand-building of the kind typified, for example, by the anti-industry attitudes that have typified not only craft but much modernist visual art production. Rather, this approach to technology is identified as a point of comparison in establishing the enormous tensions that exist between technology and the realization of subjectivity and well-being in contemporary life.

Nevertheless, one area where holistic technologies have remained viable in modernity has been in the arts. As the anthropologist Daniel Miller has argued, a primary role of art within modernism has been, paradoxically, to provide commentary on modernity's fragmentation of life into abstract areas of interest and specialization.[11] This has obvious pertinence to Favro's examination of industrial technologies, whose histories his work quotes and recalls, even commemorates. However, it is another of Franklin's insights that makes it possible to take this relationship somewhat further. As she notes, the reception of technology is not uniform but takes place in phases. Beginning with a kind of youthful enthusiasm, an atmosphere of hope, imagination and anticipation associated with the introduction of new technologies, Franklin argues they eventually become standardized

and institutionalized. She cites the motor car. In relatively short order it went from a source of personal freedom to a costly necessity that is a major threat to the very quality of life it originally enhanced. In this cycle, Franklin notes, the individual moves from having a knowledge of the technology and often considerable interest in it, and therefore a sense of personal connection if not control, to a dependence on costly experts and specialists.[12] This will be familiar not only to car owners but also, for example, to everyday computer users. It is part of the frustration and disappointment of the experience of modernity that Marx had in mind in his phrase "all that is solid melts into air."

Favro's machines seem to articulate the optimistic, early phases of modern technologies. Built by hand from an assumed position of a comprehensive knowledge inimical to the divisions of labour and function characteristic of modern technologies, they are located at a point before the relationship between the individual and technology, and between technology's function and its effects, have turned sour. Yet these are not, for instance, the nostalgic, painstaking historical re-creations of steam engines or model trains and airplanes made by hobbyists. Assembled somewhat roughly from available materials, Favro's machines are not about replication or finish. Rather, he disturbs the mimeticism of his machines and the rational principles that underpin them by plays on scale, materials and function, as well as the ambiguous effects of *trompe l'œil*. Generating low-key, sometimes humorous, yet always provocative dissonances, these tinkerings are a constant reminder that these works are also located in and made from the perspective of a time when the alienating effects of mature prescriptive technologies have been absorbed and largely naturalized as a part of everyday life and experience. They may hold out the idea of technology as wonder but never allow it to quite settle or gel. Indeed, if there was ever a question that this work involved a utopian view of machines or was even principally about machines themselves, it would seem to be laid to rest by the hand tools Favro has made in the past few years. In the context of the work that precedes them, they do not seem so much about technology as the principle of personal investment in technology and the presence there of the physical body.

Perspective

In the mid-1960s, Favro switched from painting to making sculpture. Nevertheless, through interpolations and reversals of illusion and reality, image and object, and two- and three-dimensions, painting and concerns related to it have retained something more than a vestigial presence in his work. This is obviously evident in the tableaux he terms "painting sculptures." *Sunlight on Table and Floor* (1990), for example, is a three-dimensional cutaway of an interior in which the play of light and shadow has been rendered as if the

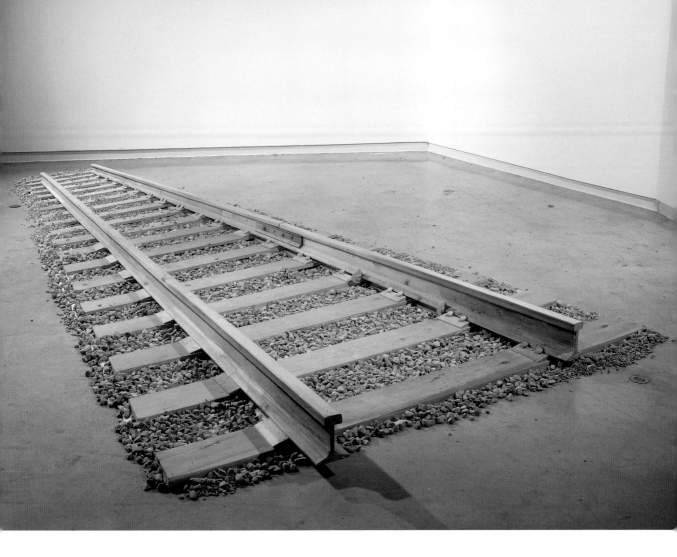

Railway Tracks 1995-96
Wood, paint, stones
25.4 x 274.0 x 610.0 cm
Oakville Galleries
[not included in the exhibition]

image was the kind of traditional naturalistic painting to which the composition refers. This is also a central concern of most of the projections. The most literal reference to painting itself is made in *Van Gogh's Room* (1973-74), which involves a three-dimensional re-creation of Van Gogh's famous painting, but it is also apparent in the use of the painting convention of still life in works such as *Washing Machine* and *Still Life (The Table)* (both 1970). It was in *Van Gogh's Room* and *Washing Machine* that Favro initially made three-dimensional forms in terms of linear perspective, an effect that he has used again in recent sculptures including *Hydro Pole* and *Railway Tracks* (both 1995-96) and *SD40 Diesel Engine* (1998).

Favro's change to sculpture coincided with a growing critique of formalist abstract painting. Though not Favro's target as such, much of

his work since that time could be read as satire or even revenge on what has been the predominant theorization of modernism in the visual arts. Articulated most notably by the critic Clement Greenberg, formalism dismissed experience and narrative from art in favour of what it understood as an investigation of the intrinsic material properties of the medium. As one writer has put it, Greenberg squeezed space out of painting like juice from an orange.[13] What was left was a pure, non-illusionistic, optical experience consistent with the ostensibly essential nature of a painting. In these terms, Favro's works are brazenly impure. They abandon two dimensions for three; introduce techniques of spatial illusion that had been completely discredited in advanced modernist painting practices since the Impressionists; and, in the case of the projections, substitute projected colour slide images for the descriptive and decorative functions of paint. As significantly, these works open up the experience of an artwork from what had been reduced to an extreme form of ocularism to an encounter that is both physically dynamic and engaged. And this is not to mention content (which will be considered later).

Greenberg's formalism is a kind of *reductio ad absurdum* of Cartesian perspectivalism, the foundation for modern forms and theories of knowledge. Characterized by what has been described as the hegemony of the eye in western culture, perspectivalism developed in the wake of the Renaissance invention of linear perspective, transposing perspective's abstract and mathematical construction of a grid-like space to an all-encompassing understanding of how the world is organized.[14] This privileging of visuality has been contested on many grounds. A number of these criticisms are pertinent here. Aside from its questionable physiological basis, critics have argued that perspectivalism produces an especially problematic subject: all seeing and knowing yet inert and, in terms of perception, essentially passive or reactive. This is a subject who is both authoritarian and emotionally straightjacketed. As perspective rationalized the space of painting, rendering it uniform, timeless and fixed, space itself came to be emphasized over the objects represented in it. Similarly, it has been argued that perspectivalism asserts its own orderly, mechanistic understanding of the world, providing a framework, for instance, for modern science and technology but downgrading whole ranges and categories of experience that fall outside these terms of reference.

In a discussion of perspective, the intellectual historian Martin Jay notes, "It was...this space that differentiated the dominant modern world view from its various predecessors, a notion of space congenial not only to modern science, but also...to the emerging economic system we call capitalism."[15] Jay refers to Raymond Williams' argument (made with reference to agriculture) that perspectivalism made possible a radical separation between the spaces of work and consumption critical to capitalism, setting up a differentiation between those who worked the land and those who viewed it, and between those who see and those who are seen.[16] It is no coincidence that these arguments coincide in

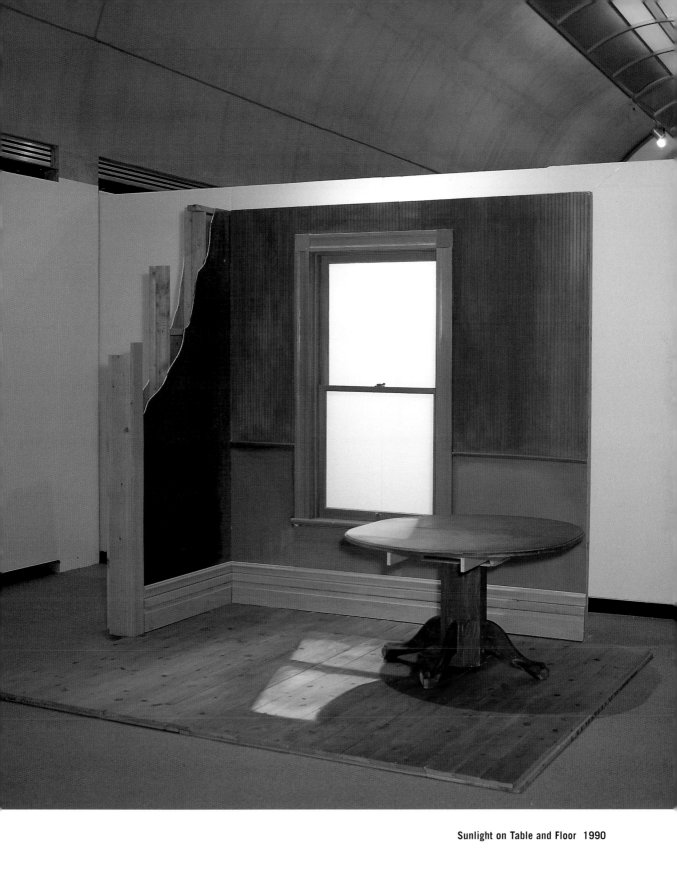

Sunlight on Table and Floor 1990

many ways with Ursula Franklin's analysis of prescriptive technologies dating from the Industrial Revolution. In particular, they involve similar observations about divisive, hierarchical forms of social organization, the structure of knowledge, and the consequences for subjectivity of oppositions between knowledge and experience and body and mind. In terms of Favro's art, it is apparent that within the wider context of modernity his relationship to technology and the questions related to vision that his work raises are very much of a piece. In these terms, his use of perspective is an especially acute and telling trope.

In many of his works that deal with sight and vision, Favro seems to be responding to the constricted conventions of modern visual culture. In them, vision isn't so much critiqued as its singularity is overloaded or undermined. It is as if what is seen is somehow not real enough or is inadequate to the task of representation. With their various formal and technical curveballs, all of these works are physically assertive in ways that invite viewers to interact with them bodily. In the case of the projections, it is not only possible to move through them, but in doing so it is also possible to block or intercept the projected slide image, thus underlining the contingency and fragility of both images and objects through the actions of one's own body. One of the joys of *Van Gogh's Room* is the odd exhilaration of literally walking into the piece and simultaneously experiencing its authority as an historic image and its absolute transparency as an illusion. Rather than making resolved or finished images, Favro is at pains to make the whole constructed nature of these works transparent. This ranges from the promunent display of the technical apparatuses in the projections to the appliction of paint to surfaces to a point, to paraphrase Favro, where the object is clearly a wooden thing as well an image of a real thing.

The hybrid "painting sculptures," "perspective" sculptures and the projections are compellingly unstable in terms of distinctions based on media or artistic discipline. This is also true of Favro's guitars. Favro initially makes a guitar to experiment with the kind of sounds it can produce. However, when he is finished with it, he hangs it up as sculpture. Conventionally, distinctions have been made between the guitars as working instruments and sculpture, yet this opposition does not reflect Favro's own thinking or approach. Instead, the different functions of his guitars take their place within his overall practice, about which, it has to be added, Favro does not make significant differentiations in terms of producing visual art and making noise within the collective structure of the Nihilist Spasm Band. These interconnections are important because, even as they point to the interdisciplinarity and range of Favro's practice, they also underline that its power and edge are directly related to its refusal of the hierarchies that circulate around it. In this regard, not only is Favro's conception of noise music instructive, but so is the way it is produced. Stripped of the melodic structures of western music and even the modulated patterns of improvised free jazz, the *modus operandi* of the Nihilist Spasm Band is to explore sound as energy through a process of disciplined reciprocity and interaction.

Produced by an encompassing mix of physical, emotional and mental drive and what at this point is more than twenty-five years of shared history and experience, the process, not to mention the noise that results, could not be more removed from the instanteous vision of the isolated, disembodied eye imagined by the tradition of perspectivalism.

Conclusion: The Everyday

In considering Favro's career, it is apparent that much of his work is connected to the everyday. This can be itemized as a virtual iconography: domestic settings (living room, bedroom, front steps and porch, cottage wharf); domestic objects (washing machine, coffee pot, skis, bicycle, homemovie camera, electric guitars); the workplace (the studio, shop tools and equipment, reference books, band practice); familiar and/or popular technologies and landmarks (hydro pole, airplanes, trains, film projectors, Van Gogh). Though not identified as such, much of this iconography is directly associated with Favro's personal and professional life. The hydro pole is situated outside his studio window (and can be seen reflected in *Studio Window*). *SD40 Diesel Engine* is manufactured in London not far from his studio. Skeleton Lake, the site of his wharf piece, is located near Huntsville, the town where Favro grew up and has returned for vacation. The Sabre Jet invokes not just a fascination with aviation but, more particularly, with the Avro Arrow, the shining symbol of Canadian technology from Favro's youth in the 1950s that has subsequently become a part of national mythology. Favro's bicycles can be linked to his friend and colleague Greg Curnoe. The late artist was not only an avid cyclist but he made bicycles the subject of several well known series of works. Favro's guitars are also related to Curnoe, who was one of the founders of the Nihilist Spasm Band. The band, of course, is also referenced here. This association has played a particularly large role in Favro's career. Its importance may be measured not only in the band's public concerts and recordings, which are relatively limited, but also in the more than twenty five years that it has been practicing on a weekly basis and all that entails in terms of collaboration, group knowledge and commitment.

This enumeration could go on, but it should be evident that Favro's work and practice are thoroughly infused in a mix of the personal, community and the local. Given Favro's connection with the control of his production and the animating importance in his art of the world of everyday experience, there is also a kind of class identification that can be associated with his work. This is nothing so overt or particular as a working class or middle class consciousness but does relate to the question of subjectivity in relationship to larger economic and social structures that is such a significant leitmotif of his work. The world of the basement or garage workshop, the creative solution to mechanical issues through available materials, a certain matter-of-factness and refusal or

skepticism about specialization and finish are subject and social positions that are strongly evoked in his work.

The everyday may operate in a generic or generalized way in Favro's practice but its place there as subject matter is neither incidental nor conventional. Its situation can be related to a recent reassessment of how perspective was understood by artists of the Renaissance (rather than subsequent philosophers and theorists). Briefly, the argument goes that historically, the geometrically idealized space produced by perspective, dazzling in its uniformity and rational perfection, came to be privileged over subject matter, thus setting in motion, in terms of art at least, centuries of pruning content in favour of form. Yet for artists to whom perspective was initially introduced, its significance was not only as a new concept of space but as a means for rendering objects located in it more convincingly.[17] Favro seems to have understood something similar in his own plays on the ocularcentric tradition of perspective. The everyday may not function as extrinsic content or narrative in his work but it is inseparable from consideration of its production or meaning.

It was suggested earlier in this essay that the task of art in modernity was to provide perspective on the fragmentation of modern life. Nonetheless, this involved a large paradox because, like other disciplines, art itself was a fragment. In these circumstances, anthropologist Daniel Miller argues, art sought totality elsewhere.[18] Miller is particularly interested in how art looked to or appropriated other cultures, yet as a philosophical basis for relating to the world perspectivalism holds out a similar sense of wholeness. As this essay itself has argued, such wholeness is an illusion that has been papered over in modernity by hierarchical oppositions, the splitting of the senses, the distancing of knowledge from experience, art from everyday life, and so on. In considering Favro's production, the critical perpsective it has maintained on this understanding of art would seem crucial. In the process of questioning and resisting the modernist framework in which it has been produced, it has persistently worked through and asserted a subjectivity strongly grounded in the everyday against the fracturing associated with that framework. No doubt this has much to do with the continuing contemporaneity of his work at a time when modernism has been so seriously challenged if not irrevocably damaged as a paradigm. In formal terms his work is succinct yet complex. In critical terms it is acute yet not didactic. In emotive terms, it is both cool and hot. The epigraph to this essay may not say it all, but when it says Murray rocks it is definitely connecting with much that is fresh and relevant in his work.

Notes

1. "Shotgun," *Lola* (no 2., Summer 1998).

2. Videotaped interview recorded July 17, 1998, for *Noisemaker*, a documentary produced for the exhibition *Murray Favro*.

3. Experiments in Art and Technology was a collaboration of artists, scientists and technicians exploring the use of advanced technology as an artistic medium. An exhibition at the Los Angeles County Museum of Art in 1971 representing projects developed during the two previous years turned out to be the culmination of EAT. Among the artists included in the exhibition were Claes Oldenburg, Robert Rauschenberg and Tony Smith.

4. Some of the other artists were Greg Curnoe, Ron Martin and David Rabinowitch. Under the imprint of Mechanology Press, Hart published at this time *Reflections on the Science of Machines*, an English translation of a text by Jacques Lafitte, originally published in Paris in 1932 (vol. 21, "Cahiers de la Nouvelle Journée Librairie Bloud & Gay"). Hart touches on a number of his concerns in his preface.

5. Stephen F. Mason, *A History of the Sciences* (New York: Collier Books, 1968), 154.

6. Ursula Franklin, *The Real World of Technology* (Toronto: CBC Enterprises, 1990).

7. From 1965 to 1968 Favro built *Half-Size Sabre Jet*. The work no longer exists.

8. Maxine Berg, *The Machinery Question and the Making of Political Economy, 1815–1848* (Cambridge: Cambridge University Press, 1980).

9. Franklin, ibid, 59.

10. Ibid, 31.

11. Daniel Miller, "Primitivism and the Necessity of Primitivism to Art," in Susan Hiller, ed., *The Myth of Primitivism* (London and New York: Routledge, 1991), 50-71.

12. Franklin, ibid, 98.

13. James Elkins, *The Poetics of Perspective* (Ithaca and London: Cornell University Press, 1994), 23.

14. Martin Jay, *Downcast Eyes: The Denigration of Vision in Twentieth-Century French Thought* (Berkeley and Los Angeles: University of California Press, 1994), 54-60.

15. Ibid., 57.

16. Ibid., 59.

17. Elkins, ibid. Elkins argues that the notion of space as it has been understood since the Renaissance did not exist at the time.

18. Miller, ibid.

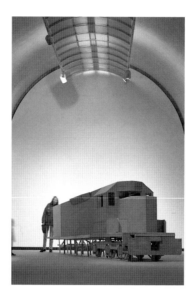

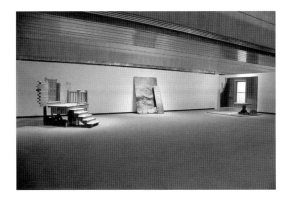

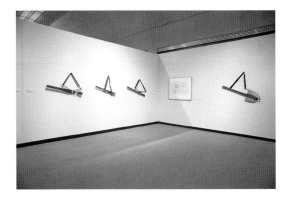

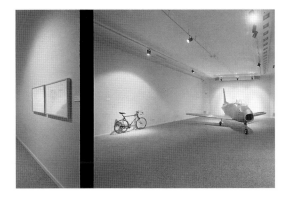

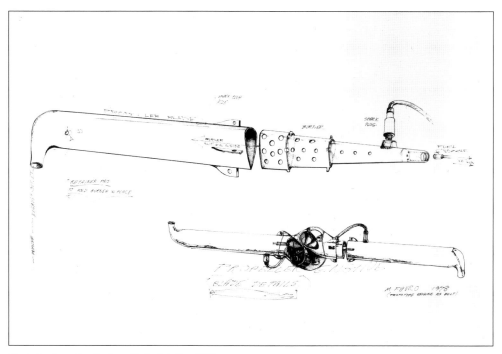

Study for Propeller Engine: Blade Details 1978

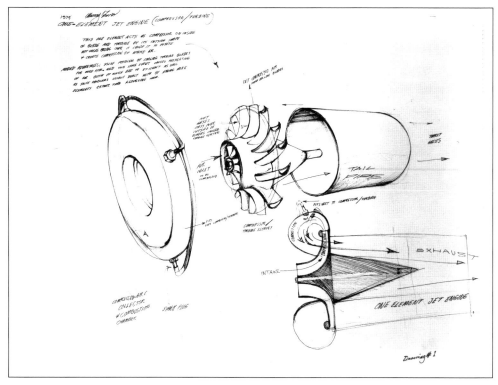

One-element Jet Engine (Compressor/Turbine): Drawing No.1 1975

WORKS IN THE EXHIBITION

Dimensions are given in centimetres; height precedes width precedes depth.

SCULPTURE AND RELATED WORKS ON PAPER

Propeller Engine 1978
Steel, aluminum, hardware
151.1 × 132.7 × 90.2
Art Gallery of Ontario

Sabre Jet, 55% Size 1979–83
Aluminum, steel, fibreglass, plexiglass,
aircraft hardware
256.0 × 603.0 × 650.0
National Gallery of Canada

Rear Pedals Bicycle 1988
Life-size bicycle and paint
101.0 × 162.0 × 40.0
The Art Bank, Canada Council for the Arts

Sunlight on Table and Floor 1990
Wood, metal, paint
261.6 × 302.3 × 264.2
National Gallery of Canada

Wind Tunnel 1990
Wood, lights, fan
100.0 × 286.0 × 94.0
Montreal Museum of Fine Arts

Rear Pedals Bicycle #2 1991
Welded steel, black paint, rubber and
plastic, life-size bicycle
93.4 × 153.0 × 40.0
Art Gallery of Ontario
Gift of Carmen and Claire Colangelo

Snow on Steps 1994
Wood, oil paint
261.6 × 231.1 × 200.7
Courtesy Murray Favro/Christopher Cutts Gallery

Wharf on Skeleton Lake 1994
Wood, oil paint, aluminium
180.3 × 99.1 × 20.3
Courtesy Murray Favro/Chrsitopher Cutts Gallery

Hydro Pole 1995-96
Wood, oil paint
261.6 × 208.3 × 58.4
Courtesy Murray Favro/Christopher Cutts Gallery

Air Compressor and Turbine 1996-97
Wood, oil paint, aluminum, steel
72.4 × 139.7 × 41.9
Owens Art Gallery
Purchased with financial support from
the Canada Council for the Arts Acquisitions
Assistance Program, and the Friends of Owens
Art Gallery

Snow Plane 1997-98
Wood, oil paint, wood plane, ski hardware
15.2 × 205.7 × 7.6
McIntosh Gallery, University of Western Ontario
Purchased with the assistance of the York Wilson
Endowment, which is administered by the Canada
Council for the Arts

Wooden Anvil 1997-98
Wood, oil paint, graphite, steel
74.9 × 62.2 × 31.8
Art Gallery of Windsor

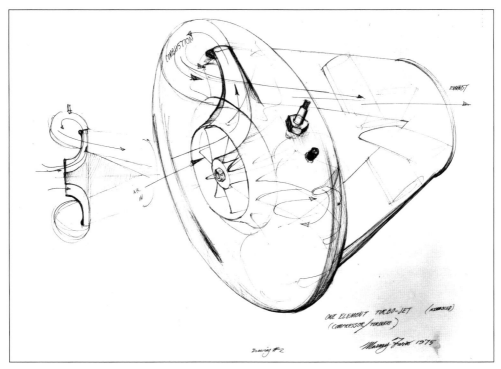

One-element Turbo Jet (Compressor/Turbine) Assembled Drawing No. 2 1975

Lever and Wheel 1997–98
Wood, oil paint, bicycle hardware
134.6 × 83.8 × 31.8
Art Gallery of Ontario

SD40 Diesel Engine 1998
Wood, paint
213.4 × 154.9 × 706.1
Courtesy Murray Favro/Christopher Cutts Gallery

**One-element Jet Engine
(Compressor/Turbine) Drawing No. 1** 1975
Pen on paper
46.0 × 61.0
National Gallery of Canada

**One-element Turbo-Jet (Compressor/
Turbine) Assembled Drawing No. 2** 1975
Pen on paper
46.0 × 61.0
National Gallery of Canada

Study for Propeller Engine: Blade Details
1978
Pen and ink on paper
30.5 × 45.4
Art Gallery of Ontario
Purchased with assistance from Wintario, 1979

Study for Propeller Engine: Fuel System
1978
Pen and ink on paper
30.5 × 45.4
Art Gallery of Ontario
Purchased with assistance from Wintario, 1979

Study for Propeller Engine 1978
Pencil, pen, ink on paper
30.5 × 45.4
Art Gallery of Ontario
Purchased with assistance from Wintario, 1979

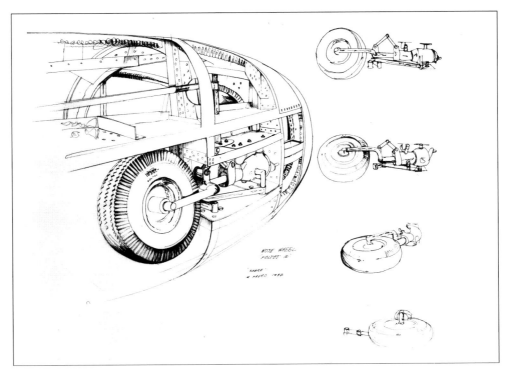

Study for Sabre Jet: Nose Wheel (Folded In) 1982

Study for Propeller Engine: Machining
1978
Pencil on paper
30.5 × 45.4
Art Gallery of Ontario
Purchased with assistance from Wintario, 1979

Study for Sabre Jet: Nose Wheel (Folded In)
1982
Ink and pencil on drafting paper
43.0 × 55.7
Art Gallery of Ontario

Study for Sabre Jet: Controls 1982
Ink and pencil on drafting paper
43.2 × 58.4
Art Gallery of Ontario

Sabre Studies ca. 1983
Pencil on paper
22.9 × 28.6
Courtesy Christopher Cutts Gallery

**Detail of Painting Sculpture − Sunlight
on Table** 1991
Pencil on paper
45.7 × 61.0
National Gallery of Canada

A Level Crossing 1996
Pencil on paper
45.7 × 61.0
Courtesy Christopher Cutts Gallery

Rail Details 1996
Pencil on paper
45.7 × 61.0
Courtesy Christopher Cutts Gallery

Rails and Ties 1996
Pencil on paper
45.7 × 61.0
Courtesy Christopher Cutts Gallery

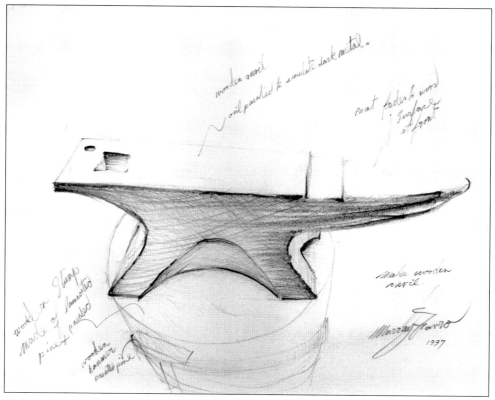

Untitled: Wooden Anvil 1997

Transformers 1996
Pencil on paper
45.7 × 61.0
Courtesy Christopher Cutts Gallery

Insulators 1996
Pencil on paper
45.7 × 61.0
Courtesy Christopher Cutts Gallery

#1 Wheel and Vibrations 1997
Pencil on paper
22.9 × 29.2
London Regional Art and Historical Museums
Gift of Ms. Catherine Morrissey, 1997

Untitled: Wooden Anvil 1997
Pencil on paper
22.9 × 29.2
London Regional Art and Historical Museums
Gift of Ms. Catherine Morrissey, 1997

Downhill Plane or Snow Plane 1997
Pencil on paper
22.9 × 29.2
London Regional Art and Historical Museums
Gift of Ms. Catherine Morrissey, 1997

Untitled 1997-98
Pencil on paper
22.9 × 28.6
Courtesy Christopher Cutts Gallery

Untitled 1997-98
Pencil on paper
22.9 × 42.7
Courtesy Christopher Cutts Gallery

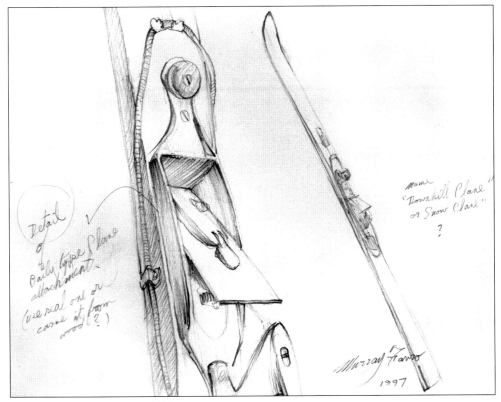

Downhill Plane or Snow Plane 1997

PROJECTIONS

Light Bulbs 1970
16 mm colour film loop, projector, timer control,
painted wood
86.0 × 91.0 × 28.0
London Regional Art and Historical Museums

Still Life (The Table) 1970
35 mm colour slide, projector, projector stand,
canvas, wood, table
74.9 × 81.3 × 91.4
London Regional Art and Historical Museums

Washing Machine 1970
35 mm colour slide, projector, mirror, wood, canvas
48.3 × 73.7 × 78.7
The Art Bank, Canada Council for the Arts

Van Gogh's Room 1973-74
35 mm colour slide, projector,
painted wood, fabric
213.3 × 365.7 × 914.4
(approximate installation area)
Art Gallery of Ontario

Studio Window 1989
Wood, motor, two colour slides,
two slide projectors
142.2 × 81.3 × 271.8
(approximate installation area)
Montreal Museum of Fine Arts

Bolex Camera 1998
Wood, paint, colour slide, slide projector
35.5 × 40.0 × 15.2
Courtesy Murray Favro/Christopher Cutts
Gallery

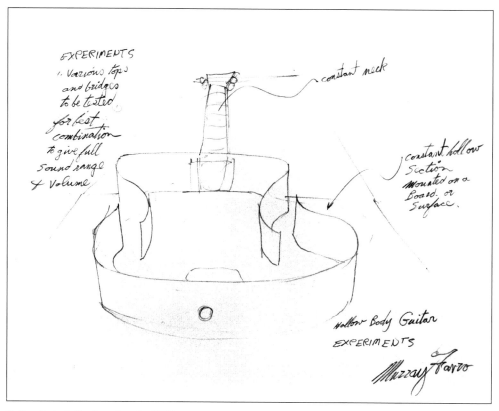

Hollow Body Guitar Experiments 1997

GUITARS AND RELATED DRAWINGS

Guitar #1 1966
Wood, masonite, enamel, guitar hardware
48.0 × 119.0 × 8.0
Collection of David Rabinowitch

Guitar #3 1967
Wood, masonite, enamel, guitar hardware
32.0 × 108.0 × 7.0
The Carmen Lamanna Collection

Welded Steel Guitar 1978
Steel
27.0 × 104.0 × 6.5
The Carmen Lamanna Collection

Welded Steel Guitar 1979
Welded steel, guitar hardware
31.7 × 118.1 × 6.3
On loan to Art Gallery of Ontario from the
estate of the late Marie LaSueur Fleming

Guitar 1982
Wood, aluminum, steel and guitar hardware
33.0 × 119.4 × 5.1
London Regional Art and Historical Museums

Guitar #1 1983
Cherry wood, strings, guitar hardware, steel
27.3 × 89.0 × 7.6
National Gallery of Canada

92

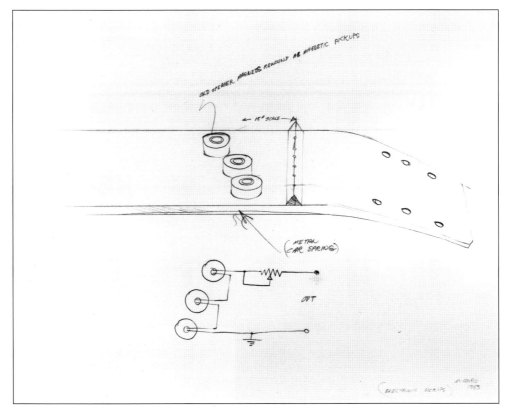

Study for Installing Magnetic Pickups 1983

Guitar #2 1983
Cherry wood, strings, guitar hardware, steel
25.4 × 92.7 × 7.6
Collection of Jay Chiat

Guitar #3 1983
Cherry wood, strings, guitar hardware, steel
24.1 × 92.7 × 8.9
Collection of Jay Chiat

Guitar #4 1983
Cherry wood, strings, guitar hardware, steel
23.2 × 81.9 × 7.0
The Carmen Lamanna Collection

Steel Guitar 1985-86
Steel, leather
11.4 × 71.1 × 6.4
McIntosh Gallery, University of Western Ontario

Hollow Body Guitar #1 1987
Wood, steel, guitar hardware, strings
32.0 × 103.0 × 10.5
Carmen Lamanna Estate

Guitar 1988
Wood, bronze, steel
33.0 × 100.0 × 15.0
Collection of Reinhard Reitzenstein and Gayle
Young

Forming Jig for Guitar Assembly 1988
Plywood, pine wood
90.6 × 41.6 × 8.7
Courtesy of Murray Favro

Forming Jig for Guitar Sides 1988
Aluminum, hardware, plywood, pine and cherry
wood
67.0 × 46.3 × 25.0
Courtesy of Murray Favro

Acoustic Hollow Body Guitar 1988-89
Cherry, mahogany, purple heart woods, bronze,
guitar hardware, string
34.3 × 101.6 × 14.0
Carmen Lamanna Estate

Brass Guitar 1993
Brass, hardware
36.0 × 99 × 15.0
The Canada Council for the Arts, Art Bank

Guitar #2 1993
Wood, guitar hardware
38.0 × 102.0 × 15.0
London Life Insurance Company

Study for Next Guitar 1978
Pencil on paper
30.5 × 45.7
The Carmen Lamanna Collection

Future Guitar Changes and Designs 1978
Pencil on paper
30.5 × 45.7
The Carmen Lamanna Collection

Study for Left-Handed Guitar 1978
Pencil on paper
30.5 × 45.4
The Carmen Lamanna Collection

Music Gallery Portfolio: Guitar Design
1982
Screenprint on paper, 4/40
44.5 x 82.8
London Regional Art and Historical Museums
Purchased with a Canada Council matching
grant and Acquisition Funds, 1982

Study for Guitar 1982
Pen and pencil on paper
35.6 × 43.2
The Carmen Lamanna Collection

Untitled: Preparatory Study for Guitar
1982
Pencil on paper
21.6 × 25.4
London Regional Art and Historical Museums
Purchased with a Canada Council matching
grant and Funds from the Volunteer Committee,
1985

Untitled: Preparatory Study for Guitar
1982
Pencil on paper
21.6 × 25.4
London Regional Art and Historical Museums
Purchased with a Canada Council matching
grant and Funds from the Volunteer Committee,
1985

Study for Construction of Guitar Neck
1983
Pen on paper
35.6 × 42.9
National Gallery of Canada

Study for Thin-Necked Guitar 1983
Pencil on paper
35.6 × 43.0
National Gallery of Canada

Study for Guitar Body 1983
Pen and pencil on paper
35.6 × 43.2
The Carmen Lamanna Collection

Tool Change for Routing Guitar Body
1983
Pen and pencil on paper
35.6 × 43.2
The Carmen Lamanna Collection

New Bridge Assembly – Guitar #3 1983
Pencil on paper
35.6 × 43.2
The Carmen Lamanna Collection

Study for Guitar #3 (Drawing #2) 1983
Pencil on paper
35.6 × 43.2
The Carmen Lamanna Collection

Study for Tilt Bridge Mechanism 1983
Pencil on paper
35.6 × 43.2
The Carmen Lamanna Collection

Study for Guitar (A) 1983
Pencil on paper
35.6 × 43.2
The Carmen Lamanna Collection

Study for Guitar (B) 1983
Pencil on paper
35.6 × 43.2
The Carmen Lamanna Collection

Study for Guitar (C) 1983
Pencil on paper
35.6 × 43.2
The Carmen Lamanna Collection

Study for Guitar 1983
Pencil on paper
35.6 × 43.2
The Carmen Lamanna Collection

Study for Installing Magnetic Pickups 1983
Pen and pencil on paper
35.6 × 43.2
The Carmen Lamanna Collection

Study for Guitars (D) 1983
Pencil on paper
35.6 × 43.2
The Carmen Lamanna Collection

Study for Guitar #4 (Drawing #1) 1983
Pencil on paper
35.6 × 43.2
The Carmen Lamanna Collection

Guitar Experiments 2 1997
Pencil on paper
22.9 × 29.2
London Regional Art and Historical Museums
Gift of Ms. Catherine Morrissey, 1997

Hollow Body Guitar Experiments 1997
Pencil on paper
22.9 × 29.2
London Regional Art and Historical Museums
Gift of Ms. Catherine Morrissey, 1997

BIOGRAPHY

BORN IN 1940 in Huntsville, Murray Favro moved to London, Ontario, in 1957. He studied at H. B. Beal Technical and Commercial School from 1958 to 1962 and in 1963-64 took special art courses at Beal. From 1962 to 1970 he was employed as a commercial artist. He is a founding member of the Nihilist Spasm Band and was also a member of The Luddites. Widely represented in major public and private collections, Favro is the recipient of numerous honours and awards, including the 1997 Gerhson Iskowitz Award for career achievement as an artist in Canada.

SELECTED ONE-PERSON EXHIBITIONS

1998

Mercer Union, Toronto

Murray Favro, Christopher Cutts Gallery, Toronto

1996

Murray Favro, Christopher Cutts Gallery

1994

Murray Favro, Christopher Cutts Gallery

1992

Murray Favro, Carmen Lamanna Gallery, Toronto

Murray Favro, Obscure, Quebec City

Murray Favro, Forest City Gallery, London

1991

Murray Favro: The Guitars 1966-1989, Mackenzie Art Gallery, Regina (curated by James D. Campbell; publication)

Murray Favro, Carmen Lamanna Gallery

Murray Favro/Installation, Forest City Gallery

Murray Favro, Josh Baer Gallery, New York

1990

Murray Favro, Carmen Lamanna Gallery

1989

Murray Favro, Carmen Lamanna Gallery

1988

Murray Favro, Carmen Lamanna Gallery

1986

Murray Favro, Carmen Lamanna Gallery

1983

Murray Favro/A Retrospective, Art Gallery of Ontario, Toronto (curated by Marie L. Fleming; travelled in 1983 to Montreal Museum of Fine Arts, Montreal; travelled in 1984 to National Gallery of Canada, Ottawa; Art Gallery of Windsor, Windsor; London Regional Art Gallery, London; Beaverbrook Art Gallery, Fredericton; publication)

1982

Eighteen Preparation Drawings to Construct a 55% Scaled Sabre Jet, White Water Gallery, North Bay

Sabre Jet Under Construction, Forest City Gallery

Murray Favro/Sabre Jet Under Construction, Carmen Lamanna Gallery

1980

Sabre Jet Under Construction, Carmen Lamanna Gallery

1978

Murray Favro at the Carmen Lamanna Gallery, Carmen Lamanna Gallery

1977

Air Show, Carmen Lamanna Gallery

1976

Inventions/Murray Favro at Carmen Lamanna Gallery, Carmen Lamanna Gallery

1975

Invention Exhibition, Forest City Gallery

1974

London Survey – Murray Favro, London Public Library and Art Museum, London

1973

Synthetic Lake, Carmen Lamanna Gallery

Murray Favro, Forest City Gallery

1972

Country Road, Carmen Lamanna Gallery

1971

Sculptural Projections, Carmen Lamanna Gallery

1968

Art Inventions, 20/20 Gallery, London

Murray Favro/Half Scaled Sabre Jet 1964-68, Carmen Lamanna Gallery

SELECTED GROUP EXHIBITIONS

1998

Bealart: 80 years of Experiment 1912-1992, London Regional Art and Historical Museums (publication)

1997

Track Records: Trains and Contemporary Photography, Oakville Galleries, Oakville (publication)

Works on Paper, Christopher Cutts Gallery

1996

Instruments by Artists, Forest City Gallery

1994

Murray Favro, Christopher Cutts Gallery

1993

Heart of London Revisited, London Regional Art Gallery

Vintage Modernist Works on Paper, Christopher Cutts Gallery

1992

National Gallery of Canada, Ottawa

Art Walk, Art Gallery St. Thomas-Elgin, St. Thomas

1990

L'art Bouge: un regard sur les Seventies, Maison de la Culture Côte-des-Neiges, Montreal

Memory Works: Postmodern Impulses in Canadian Art, London Regional Art Gallery

Nihilist Spasm Band (ca. 1960s)

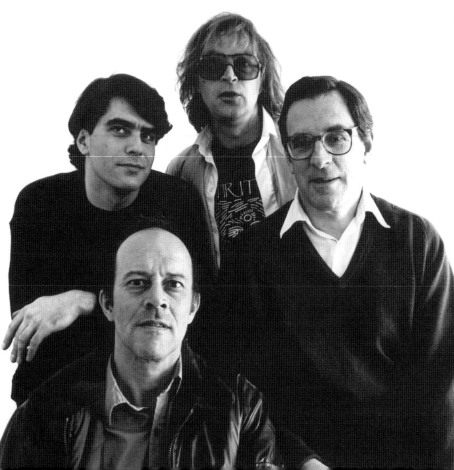

The Luddites (ca. 1980s)

1989

Scrutiny, YYZ, Toronto

The Curators' Choice, Art Gallery of Ontario

Carmen Lamanna Gallery

1988

Thunder and Lightning, London Regional Art Gallery

Casa de las americas, Galería Latinoamericana, Havana, Cuba (publication)

Carmen Lamanna Gallery

1986

How We See – What We Say, Art Gallery at Harbourfront, Toronto

Carmen Lamanna Gallery

Focus – Canadian Art 1960-1985, Art Cologne, Cologne, West Germany

1985

Icarus: The Vision of Angels, 49th Parallel, New York

Carmen Lamanna Gallery

Surface Moves, The Gallery, Stratford

1984

Quebec: 1534-1984, Outdoor Sculpture Exhibition, Quebec City

Canadian Paintings and Sculptures, 49th Parallel, New York

1983

London Artists of the 1960s, McIntosh Gallery, University of Western Ontario, London

1982

Carmen Lamanna Gallery

1981

Murray Favro, Mary Janitch, David Rabinowitch, Carmen Lamanna Gallery

The Beauty of Machines, Cambridge Library and Art Centre, Cambridge (publication)

Carmen Lamanna Gallery

1980

Murray Favro, General Idea, Joseph Kosuth, Vincent Tangredi, Carmen Lamanna Gallery

Paterson Ewen, Murray Favro, Ron Martin, Carmen Lamanna Gallery

10 Canadian Artists in the 1970s, Art Gallery of Ontario (publication)

1979

Carmen Lamanna Gallery at Galerie Marielle Mailhot, Galerie Marielle Mailhot, Montreal

Carmen Lamanna Gallery

Creative Flight, Surrey Art Gallery, Surrey

1978

3rd Dalhousie Drawing Exhibition, Dalhousie Art Gallery, Dalhousie University, Halifax (publication)

Another Dimension II, Vancouver Art Gallery, Vancouver

Murray Favro, Ian Carr-Harris, Robin Collyer, Carmen Lamanna Gallery

1977

Carmen Lamanna Gallery

Another Dimension, National Gallery of Canada, Ottawa (publication)

1976

Changing Visions: The Canadian Landscape, Art Gallery of Ontario

A Major Regional Survey, London Public Library and Art Museum, London

Drawings, Carmen Lamanna Gallery

Forum 76, Montréal Museum of Fine Arts, Montréal (publication)

Selected Sculpture London, London Regional Art Gallery, London (publication)

Graphics and Photographics, London Regional Art Gallery (publication)

1975

Carmen Lamanna Gallery at the Owens Art Gallery, Owens Art Gallery, Mount Allison University, Sackville (publication)

A Response to the Environment, University Art Gallery, Rutgers University, New Brunswick, New Jersey (publication)

Paterson Ewen, Murray Favro, Colette Whiten, Shirley Wiitasalo, Carmen Lamanna Gallery

1974

Murray Favro, General Idea, Joseph Kosuth, Carmen Lamanna Gallery

Projekt '74, Kunsthalle Köln, Cologne, West Germany (publication)

Contemporary Ontario Art, Art Gallery of Ontario

New Landscapes, National Gallery of Canada

1973

Canadian Trajectories '73, Musée d'art moderne de la ville de Paris, Paris (publication)

Boucherville, Montreal, Toronto, London, National Gallery of Canada (publication)

1972

Realism: emulsion and omission, Agnes Etherington Art Centre, Queen's University, Kingston (publication)

Toronto + London, Montreal, New York, Vancouver, Carmen Lamanna Gallery

1969

London Survey, 20/20 Gallery, London

1968

Heart of London, National Gallery of Canada

1967

27th Annual Western Ontario Exhibition, London Public Library and Art Museum (publication)

Eye and Ear '67, Carmen Lamanna Gallery

1966

26th Annual Western Ontario Exhibition, London Public Library and Art Museum (publication)

Murray Favro and Ron Martin, McIntosh Gallery, University of Western Ontario

1965

12th Annual Young Contemporaries, London Public Library and Art Museum

BIBLIOGRAPHY

PUBLICATIONS

O'Brien, Paddy. *Bealart: 80 Years of Experiment 1912-1992*. London: London Regional Art and Historical Museums, 1998.

Campbell, James D. *Murray Favro: The Guitars 1966-1989*. Regina: MacKenzie Art Gallery, 1991.

Five Artists From London, Ontario. Havana: Galería Latinoamericana, 1988. Essay by Christopher Dewdney.

Fleming, Marie L. *Murray Favro: A Retrospective*. Toronto: Art Gallery of Ontario, 1983.

The Beauty of Machines. Cambridge: Cambridge Library and Arts Centre, 1981.

Nasgaard, Roald. *10 Canadian Artists in the 1970s*. Toronto: Art Gallery of Ontario, 1980.

Curnoe, Greg and Bruce W. Ferguson. *3rd Dalhousie Drawing Exhibition*. Halifax: Dalhousie University Art Gallery, 1978.

Graham, Mayo. *Another Dimension*. Ottawa: National Gallery of Canada, 1977.

Forum '76. Montreal: Montreal Museum of Fine Arts, 1976.

Graphics and Photographics. London: London Art Gallery, 1976.

McCabe, Kate. *Selected Sculpture London*. London: London Regional Art Gallery, 1976.

Nasgaard, Roald and Karen Wilkin. *Changing Visions: The Canadian Landscape*. Toronto and Edmonton: Art Gallery of Ontario and Edmonton Art Gallery, 1976.

Carmen Lamanna Gallery at Owens Art Gallery. Sackville: Owens Art Gallery, Mount Allison University, 1975.

Wechsler, Jeffery. *A Response to the Environment*. Brunswick, N.J.: Rutgers University, 1975.

Kunst Bleibt Kunst. Köln: Kunsthalle Köln, 1974.

Canada Trajectories 73. Paris: Musée d'art moderne de la ville de Paris, 1973.

Smith, Brydon and Pierre Théberge. *Boucherville, Montreal, Toronto, London*. Ottawa: National Gallery of Canada, 1973.

Kluyver-Cluysenaer, Margreet. *Realism: emulsion and omission*. Kingston: Agnes Etherington Art Centre, 1972.

27th Annual Western Ontario Exhibition. London: London Public Library and Art Museum, 1967.

26th Annual Western Ontario Exhibition. London: London Public Library and Art Museum, 1966.

PUBLICATIONS AND PROJECTS BY THE ARTIST

"Letters to the Editor." *London Free Press*, May 31, 1994.

"DeClassification." *Provincial Essays*, vol. 4, 1987.

"The Flying Flea and Henri Mignet its Designer." (Multigraph) Toronto: Carmen Lamanna Gallery, May 28, 1977.

"Windmill Electric Generator." Toronto: Carmen Lamanna Gallery, 1975.

"Murray Favro's Journal." *20 Cents Magazine* 4, nos. 5-6, June 1970.

"Murray Favro's Journal." *20 Cents Magazine* 4, no. 4, April 1970.

"Murray Favro's Journal." *20 Cents Magazine* 4, no. 3, March 1970.

"Murray Favro's Journal." *20 Cents Magazine* 4, no. 2, February, 1970.

"Murray Favro's Journal." *20 Cents Magazine* 4, no. 1, January 1970.

"Murray Favro's Journal." *20 Cents Magazine* 3, no. 9, November 1969.

"Murray Favro's Journal." *20 Cents Magazine* 3, nos. 5-6, Summer 1969.

"Murray Favro's Journal." *20 Cents Magazine* 3, no. 3/4, May 1969.

"Murray Favro's Journal." *20 Cents Magazine* 3, no. 1/2, April 1969.

"Heart of London." Ottawa: National Gallery of Canada, 1968.

"Ron Martin's 'Conclusions and Transfers' at 20/20 Gallery – October 3-22." *20 Cents Magazine* 2, no. 1, September 1967.

REVIEWS/ARTICLES

"Shotguns." *Lola,* no. 2 (Summer 1998).

Hume, Christopher. "Favro tracks the feel of the real." *Toronto Star*, March 14, 1996.

Matyas, Joe. "Photos chronicle city's culture." *London Free Press*, May 4, 1996.

Allen, Jan. "The Iconography of Technological War." *Queen's Quarterly*, vol. 103, no. 1 (Spring 1996).

Dault, Gary Michael. "Reverie Track." *Border Crossings*, vol. 15, no. 3 (Summer 1996).

Bowering, George. "What I Saw and Heard in the Sixties." *Border Crossings*, vol. 15, no. 4 (Fall 1996).

Freedman, Adele. "Carmen Lamanna: the legend, the ledgers, the legacy." *Canadian Art*, vol. 12, no. 1 (Spring 1995).

Campbell, James D. "A Full Context for Self: Recent Works by Murray Favro." *C Magazine*, no. 44 (Winter 1995).

—————. "Murray Favro: Sculpture as Presence." *Espace*, no. 30 (Winter 1995).

Feinstein, Ron. "Report From Toronto." *Art in America*, November 1994.

Fetherling, Douglas. "The Curnoe Story: a stubborn individualist, a fierce patriot, this London artist charted a passionate course." *Canadian Art*, vol. 10, no. 2 (Summer 1993).

Enright, Robert. "Guitar Man: The Instrumental Art of Murray Favro." *Border Crossings*, vol. 10, no. 4 (November 1991).

Hume, Christopher. " 'Contraptions' give form to invisible forces." *Toronto Star,* December 16, 1988.

"New York galleries hail artists' dreams of flight." *London Free Press*, March 17, 1986.

Taylor, Kate. "Favro's guitar mount works added to LRAG Collection." *London Free Press*, December 28, 1985.

Lelarge, Isabelle. "L' Insolite au Musée, avec Murray Favro." *Vie des arts*, January/February 1984.

Mays, John Bentley. "Art - The garage mechanic esthetic of Favro." *The Globe and Mail*, April 30, 1983.

Bale, Doug. "Airplane - loving artist flying high in major Toronto show." *London Free Press*, May 7, 1983.

MacGregor, Roy. "Nobody laughs at Favro anymore." *Toronto Star*, May 8, 1983.

Dault, Gary Michael. "Art - Art Ex Machina: If machines did not exist Murray Favro would have to invent them." *Toronto Life*, June 1983.

"Murray Favro: A Retrospective." *Montreal Gazette*, October 15, 1983.

Mays, John Bentley. "At the Galleries." *The Globe and Mail*, October 27, 1983.

"White Water Gallery Hosting Art Exhibit." *North Bay Nugget*, March 6, 1982.

"Works by Murray Favro on Display at Gallery. " *North Bay Nugget*, March 20, 1982.

Newman Richard. "Grounded Jet Rising From Drawing Board." *London Free Press*, May 15, 1982.

Rans, Goldie. "Murray Favro." *Vanguard*, September 1982.

Hume, Christopher. "The artist as model-maker." *Toronto Star*, November 6, 1982.

Ludewig, Joachim. "Hier Fast Unbekannte Kunst." *Westdeutsche Allgemeinen Zeitung* (Germany), February 1, 1981.

Wilkin, Karen. "Ten Canadian Artists - And How A Controversy Grew." *Artnews,* February 1981.

Baker, Kenneth. "Report from Toronto - Ten Canadian Artists Abroad." *Art in America,* March 1981.

Audry, Rick. "Musée de l' état: dix Canadiens de l'art moderne." *Tageblatt* (Luxemburg), June 10, 1981.

"Aperçu insolite de l'art des dix dernières années." *Luxemburger Wort*, June 11, 1981.

Neumann-Baumert, Elley. "Kanadische Künstler In Staatsmuseum." *Lux-Post* (Luxemburg), June 17, 1981.

Bowen, Lisa Balfour. "Canadian Art Analyzed Carefully Abroad." *Toronto Star*, August 22, 1981.

Friedrichs, Y. "Künstler Aus Kanada Der 70er Jahre." *Das Kunstwerk*, vol. 34, 1981.

Mays, John Bentley. "Dash of Politics in AGO's Art Stew." *The Globe and Mail*, September 6, 1980.

Bowen, Lisa Balfour. "AGO Season Opener Not To Be Taken Seriously." *Toronto Star*, September 13, 1980.

Monk, Philip. "A '70s Selection For Export Only." *Maclean's*, September 29, 1980.

Fulford, Robert. "Art Gallery Neglects Young Toronto Artists." *Toronto Star*, October 4, 1980.

Murray, Joan. "10 Canadian Artists in the 1970s at the Art Gallery of Ontario."*Artmagazine,* November/December 1980.

Mays, John Bentley. "Sculpture Plucked from Mid-Air." *The Globe and Mail*, November 10, 1980.

Bowen, Lisa Balfour. "Foreign Experts Like Our Art But Wide Audience Lacking." *Toronto Star*, November 15, 1980.

Jespersen, Gunnar. "Louisiana Viser Ti Canadiske Kunstnere." *Berlingske Tidende* (Denmark), December 3, 1980.

Engelstoft, Bertel. "Lidt Modernisme." *Politiken* (Denmark), December 11, 1980.

Lassen, Hellen. "Nuditskunst Fra Canada." *Information* (Denmark), December 23, 1980.

Lehmann, Henry. "The Ontario Art Scene." *Montreal Star*, May 26, 1979.

Nixon, Virginia. "Five Toronto Artists Bring Their Works East." *Montreal Gazette*, June 2, 1979.

Viau, René. "Cinq Artistes Torontois à Montréal." *Le Devoir*, June 2, 1979.

Toupin, Gilles. "De Toronto, bien peu de choses." *La Presse*, June 9, 1979.

Mays, John Bentley. "But Is It Art?" *Maclean's,* November 5, 1979.

Keziere, Russell. "Another Dimension." *Vancouver on Review Magazine*, January 1978.

Perry, Art. "Sculptures Add Another Dimension to Art." *Province Magazine*, January 19, 1978.

Edmonstone, Wayne. "Experimental Art Exhibition at VAG for the Despairing." *Vancouver Sun*, January 21, 1978.

Redgrave, Felicity. "Halifax: 3rd Dalhousie Drawing Show at Dalhousie University Art Gallery, January 3-29." *Artmagazine*, September/October 1978.

Klepac, Walter. "The Art of Dissent." *Canadian Forum*, March 1977.

——————. "Sculpture Today in Toronto." *Vie des arts*, Spring 1977.

Frenkel, Vera. "Benign Ignorance." *artscanada*, May/June 1977.

Pope, Charles. "Another Dimension at National Gallery." *The Globe and Mail*, October 29, 1977.

Walker, Kathleen. "Motion Changes Gallery Ambience." *Ottawa Citizen*, October 29, 1977.

Elliott, Kevin. "The Philistines Are Upon Us." *Ottawa Today*, November 3, 1977.

Kay, B. "Exhibitions - Many Other Dimensions." *Ottawa Revue*, November 3-9, 1977.

Bogardi, George. "Art in Motion." *Montreal Star*, November 19, 1977.

Gingras, Marcel. "Une autre dimension: une erreur monstrueuse." *Ottawa Revue*, December 8-14, 1977.

"Motion As Another Sculptural Dimension." *Vanguard*, December 1977/January 1978.

Roque, G. "Une autre dimension." *Parachute*, Winter 1977-78.

Purdie, James. "At the Galleries." *The Globe and Mail*, February 7, 1976.

Duffy, Robert. "Anti-Mercury Crowd Aims at Wrong Target." *Toronto Star*, February 17, 1976.

Parkin, Jeanne. "Changing Visions - The Canadian Landscape." *Artmagazine,* March 1976.

Bodlai, Joe. "Murray Favro - Inventions." *artscanada*, April/May 1976.

Lamanna, Carmen. "Carmen Lamanna Gallery." *Queen Street Magazine*, Winter/Spring 1976-77.

Learn, Beth. "From Painting to Windmills/ Murray Favro - An Interview." *Queen Street Magazine*, Winter/Spring 1976-77.

Halasz, Piri. "Art at Rutgers: A Response to Environment." *New York Times,* March 23, 1975.

Crawford, Lenore. "Forest City Gallery Aptly Named." *London Free Press*, January 5, 1974.

Baker, Kenneth. "Toronto - Murray Favro at Carmen Lamanna." *Art in America*, March/April 1974.

Dault, Gary Michael. "Review/Toronto Letter." *Studio International*, April 1974.

Fulford, Robert. "Art on the Edge of Empire." *Artnews,* September 1974.

Lamy, L. "L'Art au Canada." *II Domus* (Italy), November 1974.

Rozon, René. "Le Canada au musée d' art moderne." *Vie des arts,* Summer 1973.

Schell, Win. "Interview with Murray Favro." *Applegarth's Folly*, Summer 1973.

Toupin, Gilles. "La saison des vacances et de l'art." *La Presse*, June 19, 1973.

Kritzwiser, Kay. "Paris Exhibitions Getting Coast to Coast Samplings of Canada." *The Globe and Mail*, June 12, 1973.

Borgeaud, Bernard. "Canada: Trajectories 73." *Pariscop* (Paris), June 21, 1973.

Warnod, Jeanine. "Expériences canadiennes." *Figaro* (Paris), June 26, 1973.

Ryan, Leo. "Critic Says Art Reveals Canada's Diversity." *The Globe and Mail*, June 27, 1973.

Fulford, Robert. "The Avant-Garde in Canadian Art." *Saturday Night*, July 1973.

Crawford, Lenore. "Environmental Aid - Artists, Medium, Gallery Interact." *London Free Press*, July 5, 1973.

Michel, Jacques. "Une culture en quête d' elle-même - la trajectoire canadienne aujourd ' hui." *Le Monde* (Paris), July 6, 1973.

Bergin, Jenny. "Something Happening - Eye Stopper." *Ottawa Citizen*, July 7, 1973.

Kritzwiser, Kay. "At the Galleries." *The Globe and Mail*, July 7, 1973.

Toupin, Gilles. "La Galerie nationale: de l 'art symptomatique." *La Presse*, July 7, 1973.

Bates, Catherine. "Six in One." *Montreal Star*, July 14, 1973.

Robitaille, Louis-Bernard. "Le Canada anglais découvert à Paris." *La Presse*, July 14, 1973.

Trizmiel, Marianne. "A More Reflective, Personal Form of Art." *Ottawa Journal*, July 21, 1973.

White, Michael. "Public Invited to 'Suffer Through' Gallery Show." *Montreal Gazette*, July 21, 1973.

Littman, Sol. "National Gallery Raises Some Critical Eyebrows With Newest Showing." *Toronto Star*, August 18, 1973.

Fulford, Robert. "Canadian's Uncollectable Art Enshrined by National Gallery." *Toronto Star*, September 1, 1973.

Woodman, Ross. "National Gallery Exhibit Invites Criticism, But It Is Best Ever." *Business Quarterly* (Autumn 1973).

Nasgaard, Roald. "Boucherville, Montreal, Toronto, London 1973." *artscanada,* October 1973.

Littman, Sol. "Artist's Machine Disillusioning." *Toronto Star*, December 11, 1973.

Levesque, Jean-Jacques. "L 'Art irlandais et Canadien: prémices d 'un art futur, international." *Les Nouvelles Litteraire* (Winter 1973).

Nasgaard, Roald. "Toronto." *artscanada*, December 1973/January 1974.

Kritzwiser, Kay. "At the Galleries." *The Globe and Mail*, April 29, 1972.

"Heart of London." *Art & Artists*, January 1971.

Wilson, Peter. "Canadians Fit the U.S. Mold." *Toronto Star*, May 15, 1971.

Andrews, Bernadette. "Neon Light in CNE Plastic Art Exhibit." *Toronto Telegram*, August 19, 1971.

Kritzwiser, Kay. "Art - Works for the People at the CNE." *The Globe and Mail*, August 19, 1971.

Wilson, Peter. "Colourful Sculptures Light CNE." *Toronto Star*, August 19, 1971.

Dewdney, Keewatin. " Form-Image Replicas: Murray Favro." *artscanada,* August/September 1971.

Lord, Barry. "Art - How Beal Tech has made London a Visual Arts Centre." *Toronto Daily Star*, January 24, 1970.

Wilson, Peter. "Sculpture Show." *Toronto Daily Star*, August 15, 1970.

Dault, Gary Michael. "Murray Favro, Carmen Lamanna Gallery, November." *artscanada,* February 1969.

Lord, Barry. "Swinging London." *Star Weekly Magazine*, January 13, 1968.

Martin, Ron. "Murray Favro At 20/20 Gallery." *20 Cents Magazine*, February 1968.

Crawford, Lenore. "Favro's Art Invention Show Mixes Guitars, Sabre Jets." *London Free Press*, April 23, 1968.

Kritzwiser, Kay. "At the Galleries." *The Globe and Mail*, November 9, 1968.

Dexter, Gail. "Art." *Toronto Daily Star*, November 14, 1968.

Andrews, Bernadette. "Portrait of the Artist as a Winner." *Toronto Telegram*, November 28, 1968.

"One-Man Shows." *The Five Cent Review*, December 1968.

James, Geoffrey. "The Heart of London." *Vie des arts*, Winter 1968-69.

Vincent, Don. "They Share a Direct Force of Expression..." *artscanada,* August/September 1967.

Woodman, Ross. "London (Ont.): A New Regionalism." *artscanada*, August/September 1967.

Blatchford, Karen. "Art: Still Another Artist Tries Shaped Canvas." *Toronto Telegram,* December 2, 1967.

Kritzwiser, Kay. "At the Galleries." *The Globe and Mail*, December 2, 1967.

Dexter, Gail. "Art." *Toronto Daily Star*, December 9, 1967.

Trottier, Gerry. "Murray Favro and Ron Martin at the McIntosh, December 5-January 7." *20 Cents Magazine*, November 1966.

McPherson, Hugo. "Murray Favro and Ron Martin at The McIntosh." *20 Cents Magazine*, December 1966.

Crawford, Lenore. "Exhibit by Two London Artists Draws Praise." *London Free Press,* December 13, 1966.

NIHILIST SPASM BAND

Saunders-Arriata, Phil. "Bring the Noise: The Nihilist Spasm Band helps to bring the world to London." *Scene* (London), March 12, 1998.

Baise, Greg. "Old Farts at Play." *Metrotimes* (Detroit), September 10, 1997.

Pareles, Jon. "A Really Old Band Makes a New York Debut." *The New York Times*, August 28, 1997.

Moule, Richard. "Transcending Generations and Making Anti-Music." *Scene* (London), January 9, 1997.

Stevens, S. C. "The Legacy of the York Hotel." *Scene* (London), January 9, 1997.

Westmacott, Gord. "Nihilist Spasm Band: Willing to Destroy to Create." *Scene* (London), January 9, 1997.

Portis, Ben. "The Nihilist Spasm Band Hits The Empty Bottle." *Scene* (London), January 23, 1997.

Gilliespie, Ian. "Snags at Stratford procede opening curtain." *London Free Press*, May 21, 1997.

————. "Nihilist Spasm Band begining Japanese tour." *London Free Press*, March 6, 1996.

"Review" *Scene* (London), November 4 - November 17, 1993.

Reaney, James. "The infamous Spasms: Moments of lyrical beauty." *London Free Press,* December 3, 1993.

Gillespie, Ian. "Déja vu at the York." *London Free Press*, October 19, 1990.

"The Spasm's mid- '60s reign at The York." *London Free Press*, October 19, 1990.

Kucherawy, Dennis. "Nihilist's music still causes spasms." *London Free Press*, May 18, 1979.

Freedman, Adele. "Music of Cruelty." *Fanfare: The Globe and Mail,* February 8, 1978.

"Spasm band moves to Victoria Tavern." *London Free Press,* October 9, 1971.

Crawford, Lenore. "The Spasms: unpredictability hallmark of London's Nihilist group on homemade instruments." *London Free Press*, February 3, 1968.

Harris, Marjorie. "You Should See It When It's Working, It's Really Great." *artscanada,* June 1968.

Whiston, Stan. "Hub patrons pelt Nihilist Spasm Band." *The Gazette*, January 1967.

Fair, Grant. "Nihilist noise numbs York Hotel." *The Gazette*, October 7, 1966.

ACKNOWLEDGMENTS

I am very pleased to thank the staffs of the London Regional Art and Historical Museums and the McIntosh Gallery for all of their efforts and mutual cooperation on this project. At LRAHM I worked particularly closely with Chris Alred, Bob Ballantine, David Bobier, Becky Boughner, Barry Fair, Harold Hamer, Peter Hillborg and Ruth Anne Murray and at the McIntosh with David Falls and Susan Skaith.

The exhibition included *Noisemaker*, a video made specifically for the project. The participation of John Clements, John Exley, Hugh McIntyre and Art Pratten of the Nihilist Spasm Band is appreciated. The video was produced with insight and wit by mach Y derm (a.k.a. Chris McNamara and Dermot Wilson). Band member John Boyle could not be there when the band's rehearsal was taped but he kindly lent archival materials that were important to the realization of the video.

It has been my pleasure to work on this publication with Robert Fones, Helga Pakasaar and Matthew Teitelbaum. Their essays are fresh, perceptive and add immeasurably to the critical discussion of Murray Favro's art. The extensive biography and bibliography in this publication were compiled by David Martin. The publication was edited by Mary Anne Moser and designed with much feeling for Murray Favro's work by Jennifer de Freitas of Associés libres. John Tamblyn photographed much of the work at the time of the exhibition.

During the project I have benefitted from the cooperation of individual collectors who lent works to the exhibition as well as the institutional lenders and their staffs. I would particularly like to thank Carmen Colangelo, Frank Lamanna and the estate of Carmen Lamanna, Murray Favro's dealer for many years, for making many important works available. Murray's current dealer, Christopher Cutts, facilitated many aspects of the exhibition and this publication with generosity and patience. Ron Benner and Jamelie Hassan were gracious hosts on my numerous visits to London.

This project was initiated by Ted Fraser, former director of LRAHM, and Arlene Kennedy, director of the McIntosh Gallery. I very much appreciate their invitation to work with them. Ted's commitment made the project possible. Arlene's tireless administration and her openness to both Murray's ideas and my own made the project work.

Finally, I am pleased to acknowledge my personal indebtedness to Murray Favro, an extraordinary individual and artist. Working with him has been a pleasure and an education.

Peter White

Rear Pedals Bicycle #2 1991